COLLECTING CLASSIC FILMS

COLLECTING CLASSIC FILMS

By Kalton C. Lahue

Communication Arts Books
HASTINGS HOUSE, PUBLISHERS
New York, N.Y. 10016

AMPHOTO
American Photographic Book Publishing Co., Inc.
New York

CONTENTS

PREFACE

Over the past few years, an increasing number of people have written me asking how best to approach collecting classic films as a hobby. As might be expected, I have corresponded with many senior citizens whose retirement from the world of work left a void in their lives, one easily filled by their rediscovery of a favorite pastime of years gone by—the silent movie. But most surprising to me has been the large number of young people who have recently discovered the pleasures of "old" movies for the first time. In a sense, this book is theirs.

In setting forth the advice I have given individuals for several years now, I have tried to approach the subject from the viewpoint of the would-be collector who knows very little about his new hobby. Where I have taken the liberty of presupposing that the reader has some knowledge of operating equipment, tape recording, and editing, I have done so to keep the material above the dogmatic level of an instruction manual and to allow concentration on the illumination of the many pitfalls to be avoided by both the neophyte and the seasoned collector.

To avoid the ever present possibility of producing just another equipment guide, I have deliberately limited the illustrations of projectors, editors, rewinds, screens, and so forth to a representative few, sufficient to show the diversity of choice facing the new collector. A great deal of similar equipment is offered by a variety of manufacturers; it is the reader's responsibility, using the suggestions I have put forth, to investigate the market and determine exactly what appeals to him, fulfills his requirements, and fits his budget.

Grateful appreciation is extended to the following organizations and manufacturers who have graciously furnished illustrative materials and

7

information: The Academy of Motion Picture Arts and Sciences; Baia Corporation; Blackhawk Films; D. Elmo Brooks; Burke & James; *The Classic Film Collector;* Da-Lite Screen Company; Tom Dino; Du Page Metal Products; Eastman Kodak Company; Sam Gill; Honeywell, Inc.; Wilfred J. Horwood; Hudson Photographic Industries; Kalart Company, Inc.; Keystone Camera Company; Larry Edmunds Bookstore; Museum of Modern Art Film Library; Neumade Products Corporation; Paillard, Inc.; Park Camera of Los Angeles; and Raygram-Hornstein; Billy West. My most sincere thanks go to Catherine Bollwark for her helpful contributions.

KALTON C. LAHUE

INTRODUCTION

Few hobbies are as rewarding as collecting classic films. I know. In the golden age of the movies, I wrote hundreds of film scripts. Watching the regrowth of interest in the silent film over the years, the thought has often occurred to me that a throwaway line written by the Immortal Bard three centuries ago probably describes the rewards of classic films as well as could any modern writer, "Perchance to dream."

As the collector, his family, and his friends view a favorite old movie, they cannot help but dream of that other day—the day when that movie was new, when the hero and heroine were young, and when every audience was youthful at heart. I recall those days well, for when the silent films were new, I was fairly young myself, and from 1915 to 1927 I toiled in the vineyards creating dreams.

From the beginning "dream" and "dream quality" were associated with movies in the mind of the public, as well as in the words of the paid critics. And why not? Dreams had prepared mankind for motion pictures eons before the first one was made. To the collector it is interesting that "dream quality" was obvious in the very earliest movies, such as Méliès' *A Trip to the Moon* and a French comedy that showed furniture moving itself out of a house, down the street, and into another house. When the nightmarish *The Cabinet of Dr. Caligari* came along in 1919, audiences responded instinctively to the distortions and borrowings from mankind's dream world—the same world that inspired horror films, the Keystone Comedies, and serial cliff-hangers.

For the perceptive collector, another kind of dream is implicit in classic films. The dream of fame and fortune that inspired players on the screen and those who worked behind the scenes. "All the world's a stage,

9

and all the men and women merely players. They have their exits and their entrances. And one man in his time plays many parts." William Shakespeare wrote these words almost 300 years before the first movie was produced. He knew people. He knew that there is a bit of ham in every man, woman, and child. He knew that every human has acting skill to some degree and uses that skill every day, if only in front of a mirror. The urge to act! When the first movie camera was set up on a city street, people tried to show themselves to the lens, and some became so popular that their faces became the faces of trusted friends to millions around the world.

With the advent of the motion picture, Shakespeare's words took on both a literal and a profitable meaning. Movies meant jobs, especially for girls who did not have much opportunity after leaving high school. Although most of American society might have frowned upon these girls in those days, the movie industry welcomed each and every one of them. In the studios I soon learned that there was nothing rare about acting ability, but the mighty Shakespeare could also have mentioned that all of us are not merely players on the vast world stage, we are critics of one another's performances. Generations of amateur critics, paying their way at the box office, helped to make the movies great. Now, critical study of the silent film is an added pleasure for the collector.

Early movies are true Americana. Each film speaks for itself and for its times, which, viewed in retrospect, seem happier. According to the paid critics, these are "escape films." But what is really wrong with an escape to innocence and an attempt to recapture the simplicity of less complicated days? Those of us who made the movies had no idea at the time that our work would be around to haunt us a half-century later. We tried hard in those days, but had we realized that the films we were making would live on as social documents, we would have tried even harder to make them even better.

As a collector of classic films, you are about to embark on a hobby which will bring you many hours of enjoyment. If you follow the diverse paths set before you by the author, you will acquire new knowledge and an insight into the spirit that made America loved, respected, and even feared across the globe in those hectic years before the screen learned to talk.

FRANK LEON SMITH
NEW YORK CITY

10

CHAPTER I
WHAT'S IT ALL ABOUT?

Don't be embarrassed! Now that you have picked up this book, you have a perfect right to ask the question, what are classic films and who in the world collects them? The answer is not at all startling. Collectors number over 50,000 in the United States and Canada—people just like yourself—and their ranks are increasing every year. Countless others around the world also collect, giving this rapidly growing hobby a world-wide fraternity of interest.

WHAT ARE CLASSIC FILMS?

Loosely defined, classic films encompass a wide variety of motion pictures—comedies, dramas, newsreels, and serials. All were professionally produced entertainment films, originally made for theatrical release. Stag, burlesque, girlie, and art films as well as home movies remain outside the definition of classic films. More precisely, most collectors prefer to restrict the meaning to the silent Hollywood productions of 1896 to 1930 vintage, but a growing number now consider some of the early talkies to fall within the province of their collections.

AN ACTIVE HOBBY

Rich man, poor man, young, or old—it matters little. Classic films have become the newest objects of a leisure-oriented society. But is it really as important a hobby as all that? You bet it is. Four years ago, several hundred confirmed collectors formed the Society for Cinephiles, Ltd., an association which holds annual conventions with members attending

from all over the country. These meetings of the clan, or Cinecons, have been held in Indiana, Pennsylvania, Wisconsin, Chicago, and Hollywood. Cinephiles and their families trek to the Cinecon every Labor Day weekend for three days of talks, discussions, screenings of rare films, and good fellowship. Representatives from Eastman Kodak, Blackhawk Films, and other photographic and film distributors sit side by side with collectors and listen in awe as well-known silent stars like Colleen Moore (see Fig. 1-1) deliver the keynote address. Cinephiles who can't wait for the annual conventions to roll around even hold regional meetings between Cinecons. This may strike some as a peculiar form of madness, but if so, remember that it is not restricted to the United States alone. An organization similar to the Cinephiles has recently been formed in Argentina, and a variety of collectors' clubs exist in England and France.

Fig. 1-1. Silent star Colleen Moore delivered the keynote address at the third Cinecon in Chicago (1967) after being introduced by Samuel K. Rubin, editor and publisher of **The Classic Film Collector.** Miss Moore had just completed her autobiography, **Silent Star.** Her recollections of the old days left no doubt in the minds of her audience that Hollywood today no longer has the glamour it was once noted for.

THE APPEAL

How do people become interested in classic films? Many simply discover the hobby by accident. Its novelty attracts their attention and appeals sufficiently to draw them into the collectors' ranks. Some make their initial contact with classic films at their local library; over 370 public libraries across the nation have added silent films to their circulating collections, to be checked out just as their books and records.

Other collectors like John Hampton developed a strong affection for silent films as youngsters. John lives the life every serious collector dreams of—he and his wife Dorothy operate the Silent Movie Theatre (see Fig. 1-2) in Los Angeles, the mecca which all classic film collectors hope to visit sooner or later (many do) and the only successful private venture of its kind in the world. John Hampton has put his hobby to work in a unique fashion. He shares it with the public and is paid for the pleasure!

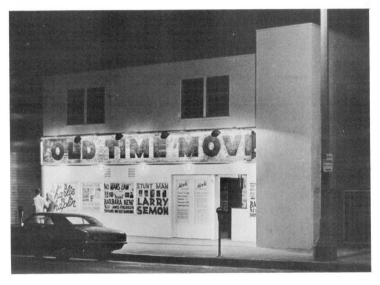

Fig. 1-2. Owned and operated by John Hampton and his wife Dorothy, the Silent Movie Theater on Fairfax Street in Los Angeles is the only commercially successful venture of its kind devoted entirely to the exhibition of silent films. Many of today's stars can be found in the audience studying the acting techniques of the greats of yesteryear.

Still others, such as the author, discovered classic films as an adjunct to their profession. As a teacher of American history, some years ago I became interested in the potential of early newsreel footage to bring William McKinley, Theodore Roosevelt, William Jennings Bryan, and others to the classroom in a living, almost breathing form which added a sense of immediacy to the dry, lifeless pages of a history book.

MORE THAN A PASSING FANCY

I could go on almost indefinitely in pointing out the varied ways one becomes a collector, but as the ways are infinite (and even exotic in some cases), it is probably better at this time to explain more about classic films and the act of collecting them, which can be transformed from a static pastime of acquisition or accumulation to a more useful, living hobby. Few collectors are as fortunate as John Hampton in transforming their hobby into a profession, but many avenues exist whereby the pastime can become more than just collecting. Here are a few ways in which active collectors have integrated their classic films with other interests.

Classic Films in Education

Teachers have long been aware of the advantages of combining films with books, but in the past high rental rates and difficulties in booking and obtaining just what they wanted proved to be an obstacle. These considerations no longer bother John Williams, a teacher of language arts in the Los Angeles public schools. John has found that silent films such as *The Last of the Mohicans, Quo Vadis,* and *Lorna Doone* can become inexpensive motivators for classroom discussion of both the books and their authors.

His students react positively to the visualization of what they have read, and the lack of a sound track allows them to interpret individually within their own experience. As a result, John has found that they approach their assignments with increased enthusiasm and interest. Having discovered a way to make his collection serve useful ends, John has become a better teacher. Such films as well as the compilations of historical footage available can justifiably be placed in the school library to help in individualizing instruction, allowing the students to pursue their areas of interest and need as they see fit.

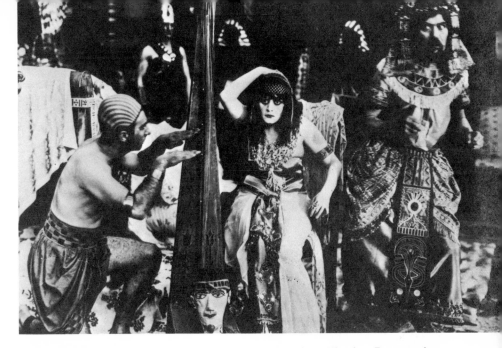

Fig. 1-3. **Cleopatra,** a Fox film of 1917 with Theda Bara, who originated the role of "vamp" or "vampire," a sultry female bent on destroying her admirers for amusement. Greatly desired by collectors, Miss Bara's films, once thought to have all been destroyed, are now rumored to be in existence. In the next few years, the collector may well be able to add one or more to his library.

Community Interests

Every community has its share of civic, church, and social clubs. All are constantly looking for fresh and varied entertainment for their meetings. Robert Jasinsky has discovered that his collection and a few lecture notes for background information have put him much in demand as a local authority, who does not have to be booked months in advance. Bob charges a small fee to help acquire additional films for his collection, reducing the cost of his hobby to almost nothing.

George Quincy discovered that his collection could help his community in another way. Since there was no theater in town, George decided to open one during the warm summer months. Charging no admission to the neighborhood youths who crowd his back lawn on Friday nights, his efforts have been rewarded by an invitation to continue showing films at the local boys' club during bad weather and the winter months. George

Fig. 1-4. Douglas Fairbanks, Sr., is still a great audience favorite with collectors in films like **The Mark of Zorro** (1920), above.

feels that in helping the kids find something to do with their free time, they have become as much a part of his interest as his films.

Study groups and college film series involving silent movies are springing up around the country, but some collectors move several steps ahead of them, entering the field of publication with their own magazines. Samuel K. Rubin of Indiana, Pennsylvania, is one of many who have started their own newsletters to help collectors keep in touch with each other. Sam's little mimeographed newsletter of 12 pages started as a speculative venture 6 years ago and has now become a 64-page plus tabloid, issued quarterly to eager collectors around the world. *The Classic Film Collector* has received mention in the national news media and has grown many times beyond the future Sam envisioned for it in 1963.

A Family Affair

All kinds of possibilities besides those mentioned exist for the collector of classic films who wishes to do more than just accumulate prints. Unlike many other hobbies, collecting films can become a family affair. Children love movies, and while mother prepares a little snack, they move chairs into place as dad threads the projector. When the lights go out and the movie starts, everyone becomes absorbed in the screen. The selection of new films soon becomes a topic of discussion around the dinner table, and the entire family participates in dad's hobby, a fact which can be of help to our head of the household when he wants to finance one of those "specials" that otherwise might put a strain on his film budget. I'm certain you can begin to see the potential of film collecting for yourself without much effort. If you have read this far, I can safely assume that you are either interested in learning more about the hobby or have already started collecting. Let's proceed!

CHAPTER II

IT ALL STARTED...

The motion picture had its beginnings with the peep shows and penny arcades at the turn of the century. Considered to be the first American story film, Edwin S. Porter's *The Great Train Robbery* provided the impetus for the growth of the nickelodeon in 1903, and by 1909 there were over 12,000 places of exhibition across the country attended weekly by 3,000,000 patrons. The public demand for canned entertainment seemed insatiable, and fortunes were made and lost with an uncanny degree of regularity. George Kleine, Samuel Long, and Frank Marion provide an example. In 1907 they pooled assets which amounted to $600 and a camera to form Kalem; by 1909 they were earning a net profit of $5,000 per week! Phenomenal success stories were the order of the day as audiences continued to pour a never ending flow of nickels and dimes into the box-office window.

By today's standards, the early films were quite primitive affairs and yet they thrilled a generation as no entertainment medium had before. One reel (1,000 feet) was considered to be the maximum length, and many reels contained at least two separate subjects, which led to their designation as *split-reels*. The motion picture turned for technique to its closest relative, the stage, and the camera became the theater-goer, fixed in position to watch the action appear on the screen at one side, occur, and depart at the other side. Nowhere was this better exemplified than in the many short films made in France by Georges Méliès and shown all over the world in the early 1900's. His *A Trip to the Moon*, the sensation of 1902, vividly shows the influence of the legitimate theater on the new art of the motion picture.

Because literary classics were a sure-fire source of story material for the new medium, dozens of famous novels found their way to the early

18

screen. In 1908 Kalem released a single reel version of General Lew Wallace's best-selling book *Ben Hur* and in the process established the concept of screen rights to novels. Henry Wallace, administrator of the Wallace estate, did not wish to see the story demeaned by connection with the motion picture and, charging infringement of copyright, sued Kalem and won $25,000 in a case which was fought all the way to the United States Supreme Court.

It is not strange that no real stars emerged from this period; actors, ashamed of their affiliation with the "flickers," tried to keep their new employment a secret from more successful friends who had a part, any part, in a theatrical play. Addressed to the character role that a particular actor or actress had recently played, fan mail was phenomenal, and the production companies did not publicize the names of actors for fear

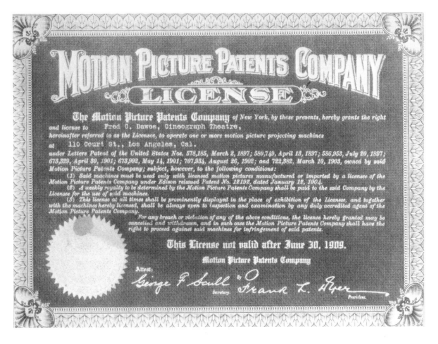

Fig. 2-1. In the early days of the movies, each theater had to pay a license fee in order to exhibit films legally. This monopoly by the Motion Picture Patents Company was soon broken up by gunfights and court battles as the industry mushroomed into one of the largest in the country.

that higher salaries would eventually result from such popularity. John Bunny, who was quite likely the first actor to realize the value of such identification, convinced Vitagraph to make use of his unusual surname in the subtitles of his comedies, which fans soon referred to as "Bunny-graphs."

Although the market continually expanded beyond belief, competition was rugged until Thomas Alva Edison asserted his patent rights in 1909 and formed the Motion Picture Patents Company, the new industry's first monopoly. Refused entrance into this select group, independent producers like William Fox and Carl Laemmle operated outside the law. Even so, ready markets existed for their wares, eventually bringing about the demise of the Patents Company and its alter-ego, the General Film Company. The business of producing motion pictures changed rapidly between 1910 and 1917. Few pioneer producers were able to keep pace with both the increasing costs of production and the forward thinking of men like Adolph Zukor, who introduced the feature-length picture as a regular program and instituted the star system.

Francis X. Bushman, Mary Pickford, Charlie Chaplin, Pearl White, J. Warren Kerrigan, Maurice Costello, John Bunny, Clara Kimball Young, Geraldine Farrar, and many others—once virtual unknowns to the majority of the American public—became audience favorites overnight, helping in the process to create the Hollywood legend. Stage actress Sarah Bernhardt appeared in *Queen Elizabeth*, lending respectability to the "vulgar flickers." By 1915 the screen was flooded with actors and actresses from legitimate theater, as well as those created solely by the motion picture industry. David Wark Griffith's *The Birth of a Nation* helped raise the silent drama to a status equalling that of the stage.

Films had progressed in length from partial reels to features of five, six, and seven reels, but not without a struggle on the part of creative men like Griffith. The fear that the golden goose would be destroyed was a very real one on the part of executives, and the pioneer companies had

Fig. 2-2. Produced on a scale never before seen in the American film, D. W. Griffith's classic, **The Birth of a Nation,** was the first motion picture to charge $2 per seat. From its first showing in 1915, the three-hour film has been the object of disagreement between civil rights groups, who claim an unfair portrayal of the Negro, and those who oppose censorship of the screen. This scene depicts Sherman's march to the sea.

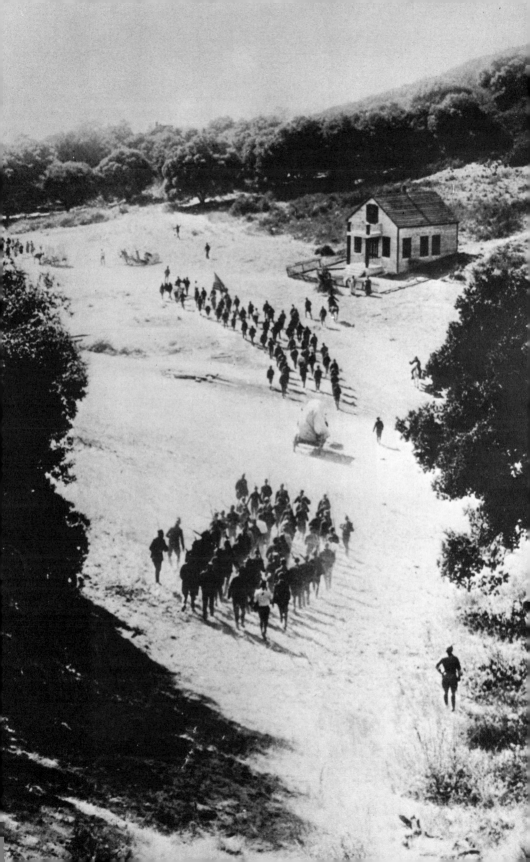

resisted longer films on the basis that the public would never sit through them. But the breakthrough gradually came in the form of multiple reel pictures like *Enoch Arden* and *Judith of Bethulia*, which were released one reel each week until all the reels had been shown. By 1911–1912, the two-reeler began to gain acceptance in the industry. Producers learned that not only would people sit still for 25 to 30 minutes but that the exhibitors would pay more for longer pictures.

The serial film made its appearance in 1912 with Edison's production of a series of stories published simultaneously in *McClure's Ladies' World*. *What Happened to Mary?* was a modest success, but the public did not really take notice of the screen chapter play until 1914. In April of that year, Pathé released *The Perils of Pauline*, and Pearl White became the toast of the nation the following day. The song "Poor Pauline" was on everyone's lips, and Pathé offered huge sums of money to those fortunate people who could accurately predict Pauline's next death-defying peril. Advertising had made its first dedicated inroads at the movies.

Fig. 2-3. Produced by Pathé in 1914, **The Perils of Pauline** remains the most famous serial ever made and is favored by most collectors. Pearl White and Crane Wilbur emote in this scene from Chapter #6, recalling the dangerous fire from which she has just escaped.

Fig. 2-4. Charlie Chaplin in **The Face on The Barroom Floor,** a Keystone Comedy of 1914. The Little Tramp has lived on long after Chaplin saw fit to abandon him and still amazes audiences with his inventive comedy routines of a half-century ago.

23

The floodgates opened and continued stories poured forth in ever increasing quantities from 1914 to 1920. The serial brought a new word into the nation's language. As producers learned to break chapter play episodes at a crucial point in the action, leaving audiences uncertain of what would happen next, the "cliff-hanger" came into its own. Serials brought stardom to an entire new group of performers, mainly women, and the emphasis on melodrama and stunt action found Pearl White, Ruth Roland, Grace Cunard, Neva Gerber, and Helen Holmes holding their own against Francis Ford, Ben Wilson, Charles Hutchison, and William Duncan.

The Keystone Comedy and its many imitators blossomed in the 1912–1915 period and introduced slapstick to the American screen. Mack Sennett capitalized upon the zany antics of what would become the

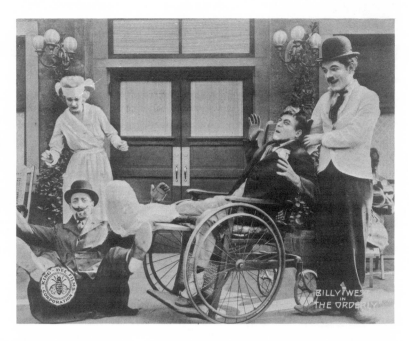

Fig. 2-5. Of the many imitators of Charlie Chaplin none came as close to the original as did Billy West. Whenever a performer wants to imitate Charlie today, he goes to Billy for instructions on the famed Chaplin shuffle.

screen's most famous band of buffoons to earn his place as the undisputed "King of Comedy." The Keystone Cops became a household favorite for describing unbelievable action. An obscure Englishman named Charles Chaplin rose from a featured player in one of the many touring English Music Hall troupes to become the world's highest paid and best-known screen performer, and Harold Lloyd began his career as a Chaplin imitator. But no one imitated Charlie as well as did a Russian immigrant, Roy Weissberg, whose likeness appeared in marquee lights across the country as Billy West and who displayed an amazing carbon copy of Chaplin's beloved "Little Tramp" character.

World War I and the recession which followed thinned the ranks of producers, and almost all of the pioneer companies disappeared to be replaced by combines such as Universal and Metro-Goldwyn-Mayer in the twenties. Independent producers still existed but found survival much more difficult. The twenties became "The Jazz Age," and critics argued whether movies created or simply reflected the nation's changing moral standards. Hollywood was rocked by scandals involving Roscoe "Fatty" Arbuckle, Mabel Normand, and Wallace Reid, great public favorites. Directors became conscious of "artistic achievement." Motion pictures were the fifth largest industry in the United States.

Movies were big business now and had acquired the respectability which wealth brought. Paramount, M-G-M, and Twentieth Century Fox emerged as the leading powers and engaged in a frantic race to replace the old Motion Picture Patents Company with new monopolies of their own, fighting each other bitterly to acquire choice theaters and locations to exhibit their films. This race brought First National and United Artists into existence, and in just a little more than one decade, the industry had changed from one in which a Kleine, Long, and Marion could start a successful business for $600 to one in which Wall Street bankers furnished the money, and the "shoe-string" producer found that keeping bankruptcy from his door was a full-time task.

Rudolph Valentino, John Gilbert, Douglas Fairbanks, Colleen Moore, Clara Bow, Buster Keaton, and Lon Chaney, Sr., were among the stars of this period who created enduring performances on celluloid and were rewarded by a public whose acclaim brought millions into the box office. Intellectuals praised the motion picture as the newest art form and sneered at Cecil B. deMille who still regarded movies as an entertainment medium and made a fortune giving the public what it wanted, skillfully masked as *The Ten Commandments* and *King of Kings*. A new

26

version of *Ben Hur* took several years to film abroad and cost the fantastic figure of almost $4,000,000 before it was completed. A struggling company near bankruptcy, Warner Brothers introduced talkies with its Vitaphone process in 1926 (sound-on-records), and John Barrymore's *Don Juan* became a dirge forewarning the silent film's death, an occasion presided over by Al Jolson's *The Jazz Singer* in 1927. Fox introduced its Movietone process (sound-on-film), and by 1930 the transition was virtually complete—talkies had replaced the silent film in 95 per cent of the nation's theaters. An era had ended and with it the careers of hundreds of actors and actresses suffered a severe jolt. John Gilbert, Rod La Rocque, Clara Bow, and Colleen Moore were among those who gave way to the generation of Gary Cooper, Clark Gable, and John Wayne. Almost immediately, nostalgia was the only response to a mention of their names.

Out of this 25-year period came thousands of films; some very good, some very bad, but the majority proved to be acceptable entertainment, just as with television programs today. A select few including *Queen Elizabeth, The Birth of a Nation, Intolerance,* and *The Covered Wagon* came to be regarded as landmarks in the development of the movies and as such possess a special appeal for today's collectors. Others such as *The Lost World* and *Ben Hur* featured superior technical achievements. Outstanding acting performances were found in *Dr. Jekyll and Mr. Hyde, The Hunchback of Notre Dame, The Phantom of the Opera,* and *The Big Parade.* Subsequent remakes have failed to match the power and spectacle of the original versions. To the collector, these films remain important, but more interesting to many is the rediscovery of films, stories, or personalities which are not as well remembered today, and therein lies a major reason for the growth of film collecting as a hobby.

The availability of less well-known films has coincided with the rising interest, for if collectors were restricted only to the available films which public and critics acclaimed as the best, few people would be inclined to invest money in the relative handful of "classic" classic films. Today, just as a half-century ago, the silent motion picture has its own individual and entertaining appeal, and this great variety of choice is another large part of the attraction of the hobby.

Fig. 2-6. Many screen lovers would do well to study Rudolph Valentino's technique in **The Son of the Sheik.** Released after his tragic death in 1926, the film proved to be his most popular and continues to be with collectors, today.

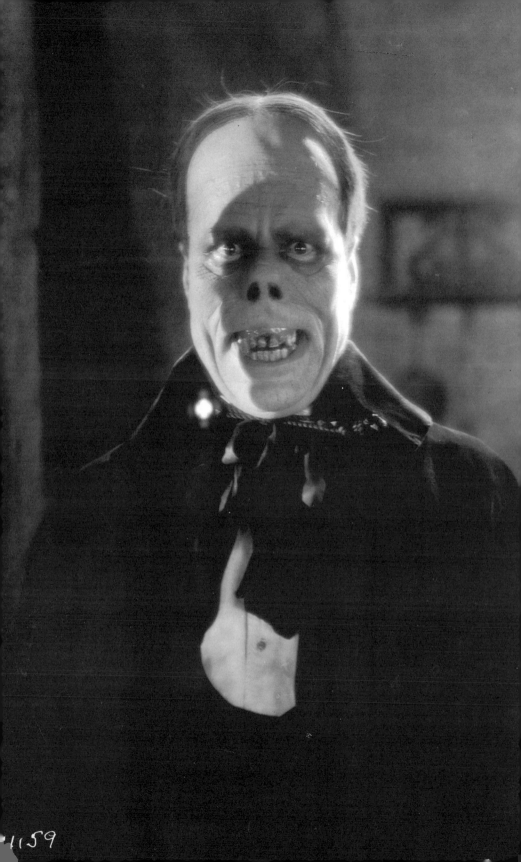

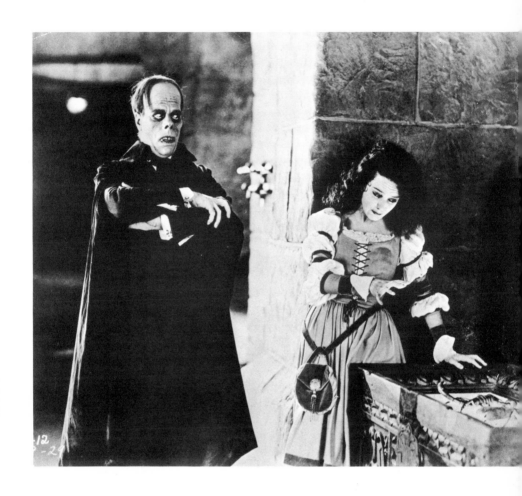

Fig. 2-7a. Lon Chaney in **The Phantom of the Opera,** a superb work of makeup artistry and a classic of the classics.

Fig. 2-7b. "The Phantom of the Opera" (Lon Chaney) reveals his secret to Mary Philbin. Remakes of this film have been pale imitations of the original.

CLASSICS OF THE FOREIGN FILM

Whereas the American silent film was unrivaled for its sheer escapism and entertainment value, the artistic leadership seems to have come from abroad. This is not to say that we did not have artistic pictures, but they were few and far between, considering the total picture, and in the silent era, as today, a sizable segment of the population looked to Europe for the "art" film. The development of the motion picture was concurrent in several countries in the late 1800's, and it is still a matter of debate among some film historians as to just which inventor achieved practical screen projection first. But details of the various claims and counter-claims can be found in the reference works cited in Appendix III; it is sufficient here to point out that America was not alone in developing a film industry. A similar growth was occurring in Great Britain, the Scandinavian countries, and the rest of Europe.

The British film never really managed to compete in the world market. Rendered quite impotent by World War I, England's film industry was overwhelmed by American imports and during the twenties was forced to struggle for survival on its own theater screens aided by government subsidies and import quotas. Few outstanding or even significant films were produced in England during the silent era and none are available at this writing from American distributors, but several of the foreign distributors listed in Appendix I offer a few English titles, along with their prints of well-known American, French, and German silents.

The Italian industry suffered the inevitable suppression of creativity under fascism and was also hard-pressed to hold its own native market; about 70 per cent of the pictures seen in Italy during the twenties were American, a sad fate for a nation which had startled the movie audiences during 1910–1913 with spectacles such as *The Last Days of Pompeii, Cabiria,* and *Quo Vadis.* Italian films owed much of their popularity in the United States to George Kleine, who imported and distributed the output of several companies during 1910–1914, but unfortunately almost none are available to collectors today; presently, only a print of *Richard the Lion-Hearted* (1912) and a reel of highlights from the lavish 1924 remake of *Quo Vadis* (with Emil Jannings as Nero), a financial failure, are within the reach of collectors.

Although quite creative until the advent of the Great War, Scandinavian films fared little better than English and Italian in the twenties. The Danish industry is remembered today primarily for the work of Carl Theodor Dreyer; Victor Seastrom and Mauritz Stiller contributed greatly

30

to the international popularity of the Swedish cinema. But both countries paid a price for creative success; their best technicians and artists were lured away, first to Germany and later to the United States, with money and promises of greater independence. Probably the outstanding Swedish film available to collectors today, *The Story of Gosta Berling* (1924), was the final great Swedish film of the silent era and marked the beginning of a most unusual career for a beauty named Greta Garbo.

Only the French film was able to survive in the twenties without government subsidization. French production was not organized in the same manner as the German or American industry. Instead of several large producers competing with each other, studios were small and often rented to producers by the picture. Although French production of the post-war period was limited by comparison with that of the United States, Germany, or even Russia, a much larger percentage of its films have been held in high regard over the years. Louis Delluc, Abel Gance, Jean Renoir, and Jacques Feyder were all creative artists in their own right, but perhaps none was more original than René Clair. A novelist fascinated by the story-telling potential of film, Clair had an instinctive feeling for the medium, and collectors can appreciate this talent today in his very first film, *Paris Qui Dort* (*The Crazy Ray*, 1923).

Fig. 2-8. Henri Rollan, as the watchman of the Eiffel Tower, walks about sleeping Paris in this scene from Rene Clair's first film **Paris Qui Dort (The Crazy Ray),** a French production of 1923. Watching this film today, the viewer finds it difficult to believe that it was made over 45 years ago.

A science-fiction story of the first order, which reveals his penetrating eye for the absurd, *Paris Qui Dort* is the tale of a group of travelers who land in Paris to find the city in a state of suspended animation and its inhabitants frozen in the grotesque situations which comprise everyday city life. They manage to find the crazed inventor whose paralyzing ray has stopped time and to restore the city to a normal state, but not before several poignant lessons have been driven home by the experiences they encounter.

The French film of the twenties carried on in the tradition set by the early French producers—Georges Méliès, Gaumont, Pathé Frères, Ferdinand Zecca, and Emile Cohl. Of this group, the collector can acquire a good representation of Méliès' films, exhibiting the many facets for which this one-time stage magician was justly famed. He was the outstanding exponent of camera magic in the form of stop-motion photography and trick films; his fantasies preceded Edison's *The Great Train Robbery*. His *Jupiter's Thunderbolts*, *Damnation of Faust*, *Witch's Revenge*, and *Paris to Monte Carlo* all hold special value for the collector interested in the historical development of the cinema. The French cinema heavily influenced the slapstick of Mack Sennett and his Keystone Cops, the artistry of Charlie Chaplin (who admitted a close relationship between his screen work and that of Max Linder, an earlier and international favorite), and the melodrama of the early serials.

The Russian film began as a direct result of French producers opening Moscow studios in 1908, but the Russian industry did not survive World War I, and it revived only as a result of nationalization by Lenin in 1919. Charged with the responsibility of disseminating education and propaganda instead of the more mundane financial incentive which led producers in other countries to provide "box-office" material for their stories, the Russian film industry produced what the Museum of Modern Art has referred to as "masterpieces of social impression"—*Battleship Potemkin*, *Ten Days That Shook the World*, *Mother*, and *Arsenal*.

Collectors can add the first two of this group to their libraries and will find both to be quite an unusual experience when compared with contemporary films made in Western countries. Directed by Sergei Eisenstein (who acknowledged a debt to the American D. W. Griffith in matters of style), the visual power and brilliant editing of *Potemkin* is an exercise in the grammar of the film. Tonal cutting, or the control of shading in a sequence for impact and emphasis; direction cutting, or the control of continuity by matching the flow of movement in one shot to that of an-

other; and cutting on form, or the curve of a stream changing to a bent arm—all are accepted cinematic techniques commonly used today. *Ten Days* expanded these techniques and their use in the same way that its story of the 1917 revolution rested in concept upon the abortive 1905 revolution, which formed the basis of action in *Potemkin*. Collectors whose interest lies in the technique of the cinema as an art form will find much to study in these two films.

In an effort to find their own sense of direction, the early German films had imitated first the French, then the Italian cinema, but during World War I Germany found it necessary to produce motion pictures in isolation. The foundations for the brilliant artistry which would bring the German film world distinction developed from within. The influence of the contemporary German theater was strongly interwoven with the film industry, and a generation of excellent craftsmen and artists dominated the scene—F. W. Murnau, E. A. Dupont, Ernst Lubitsch, Paul Leni, Josef von Sternberg, Fritz Lang, and others. Most eventually brought their

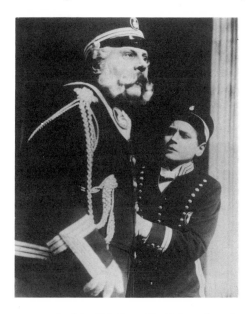

Fig. 2-9. A young man in his thirties, Emil Jannings' portrayal of the hotel doorman added 40 years to his profile and won the acclaim of critics and public alike in Murnau's **The Last Laugh,** one of the German "street films" of the twenties.

talents to Hollywood, which catered to the formula picture rather than to artistic expression, and amidst great publicity, the American studios promptly shackled their creative energies. Almost without exception, their greatest work had already been done in their own countries.

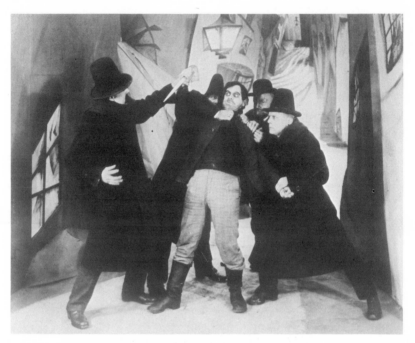

Fig. 2-10. The expressionistic decor of **The Cabinet of Dr. Caligari** reflected the warping of a madman's mind. Although its symbolism confused the American moviegoer, it made cinema history and influenced other film makers for years to come.

The "Golden Era" of the German cinema was very brief, from about 1919 to about 1925, but several of the incredible series of German films can be purchased by collectors today and prove to be striking contrasts to the American silent film. A first cycle began with *The Cabinet of Dr. Caligari,* and soon macabre films of dark imagination crossed the Atlantic to confuse, bewilder, and entice a public which had found itself unable to digest Griffith's *Intolerance* with comfort. *Caligari* is the story of a madman, but the audience does not find this out until the climax at the end. The main character suspects Dr. Caligari to be the one responsible

34

for a group of unexplained murders and thinks him to be evil incarnate; yet Caligari is actually the head of a mental institution in which the main character is confined throughout the story.

Its story-within-a-story and the original and striking decor set *Dr. Caligari* apart from its contemporaries. Nothing like it was ever attempted again, but its influence was pervasive. It opened the doorway to the personification of evil which characterized the German film in the early twenties—*The Golem* (1920), *Destiny* (1921), *Nosferatu* (1922), and others.

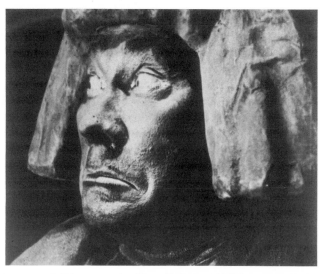

Fig. 2-11a. Paul Wegener in **The Golem** (1920), one of the earliest of horror films and a rare experience for the collector. Some historians feel that **Frankenstein** had more than a passing resemblance to this German masterpiece.

A second wave of the German film also influenced American producers. Loosely referred to by film historians as *costume spectacles*, they dealt with German history, especially of the medieval period, gradually turning to German folklore and myth. The most famous of these, *The Niebelung Saga,* was filmed in two parts and is generally referred to as *Siegfried* (or sometimes as *The Death of Siegfried*) and *Kriemhild's Revenge.* A complicated, ponderously moving adaptation of the legend so extensively used by Wagner in his operas, these films require several screenings to convey the full impact of what they are trying to say.

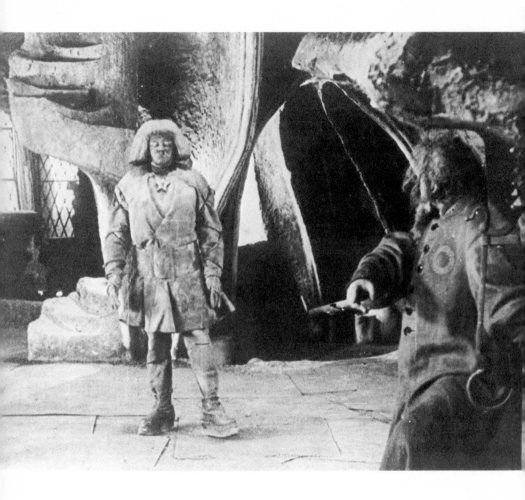

Fig. 2-11b. The creation of Rabbi Loew (Albert Steinrueck), the "Golem" was fashioned from clay and controlled by the magic amulet around his neck. When the amulet was removed in the final scenes, the monster turned to stone.

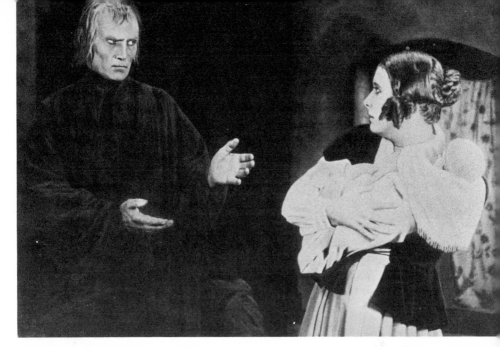

Fig. 2-12. When her love failed to prevent Life's Three Flames from extinguishing, Lil Dagover tried to bargain the life of a baby with Death (Bernhard Goetzke) for the return of her sweetheart in Fritz Lang's **Destiny** (1921).

The Germans contributed still a third variety of film in the mid-twenties, the so-called "street films" which were sympathetic with the plight of the common man in all his utter misery and used realism to an extreme. Directed by F. W. Murnau, *The Last Laugh* introduced the camera to the audience as an actor; it moved with Emil Jannings wherever he went in a striking *tour de force* which broke with the past both in technique and theory. The story is simple enough. It deals with a vignette in the life of an old doorman whose pride and joy is his uniform. When he is demoted to rest room attendant, the loss of the uniform is a staggering blow to him. Then a patron dies in his arms in the rest room, and life begins anew for the old man. The stranger has left a will which specifies that whoever is with him at the time of his death will inherit his immense fortune. Thus the old doorman has the "last laugh."

This was followed by *Variety*, directed by E. A. Dupont and photographed by Karl Freund, whose camerawork in *The Last Laugh* had been so highly praised. *Variety* has no profound story either; it is merely a slice from the life of a trapeze artist (Emil Jannings again) who kills his wife for deceiving him with another man and goes to prison. Although this film has a self-consciousness lacking in the *The Last Laugh*

and turns to melodrama instead of characterization, it proved to be an immense hit with American audiences and became a box-office smash, considered to be one of the best pictures of the year.

By 1927 the creative vitality seemed to have drained from the German film and it went into a gradual decline. Most of the top talent had been lured to America and those who had not packed their bags were awaiting an invitation to do so. Stars like Pola Negri and Emil Jannings came to the United States to reap the financial rewards of their hard work; those left behind turned to the formula picture, tailoring their work to the foreign markets in hopes of more box-office hits and so the "Golden Era" died. But one last film which is still highly regarded by collectors appeared that year, Fritz Lang's *Metropolis*.

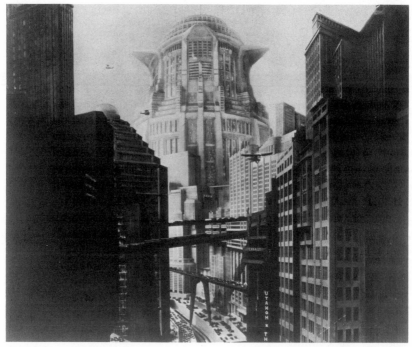

Fig. 2-13. **Metropolis,** the wonder city of the future. Scenes like this awed the American public. Although the settings were futuristic, the drama which took place below the ground was all too modern in its implications of man's inhumanity toward his fellow man.

A most imaginative look into the future told in stylistic form and philosophy, *Metropolis* is the story of a highly organized society in which mechanical labor has been developed to a fine point and the majority of human society are drones living below ground, whose work at the machines profits the ruling class living in the fine city above. This mechanization eventually clashes head-on with human dignity and love in a setting which can only be called a photographic marvel for its time. The mob scenes rival those in *Potemkin*.

One of the major differences between the foreign film and those made in Hollywood was the absence of a formula cycle abroad. A box-office hit in this country generated a wave of imitations, whereas the foreign pictures tended to be more personal and individualistic. Because other countries placed a premium at an early date on the celluloid products of their film industries, a sense of value which America still does not have, prints of these great foreign films have been preserved, and the absence or expiration of copyright protection explains why so many are offered to the collector.

But what of the cinema artists who left their homes abroad to work in Hollywood? Only Lubitsch and von Sternberg adapted easily and in so doing changed their style to one more compatible with Hollywood. With the sole exception of Leni's *The Cat and the Canary*, none of their American pictures are presently available to collectors, although some are occasionally exhibited at the Museum of Modern Art in New York and others can be rented for large sums from art film libraries. Copyright restrictions and the failure to preserve prints account for this and also explain the lack of availability of such American classics as *Ben Hur*, *The Sheik*, *The Big Parade*, and *Beau Geste*.

Pola Negri, Greta Garbo, and Hedy Lamarr were accepted by American audiences and, in surviving the transition to sound, enjoyed successful and lengthy careers. Emil Jannings and most of the other actors and actresses faded gracefully from the screen and returned home. Foreign pictures exerted an undeniable influence on the style and technique of American films for the remainder of the silent period, until sound introduced a new complication with which the movies were forced to cope. As a collector, you can share in the excitement these films generated, since the majority are as fresh and alive today as when they were first seen almost a half-century ago. Whatever your tastes in collecting, don't overlook the foreign films as possible additions to your library.

CHAPTER III
BEGINNING YOUR COLLECTION

A decade ago the variety of classic films available to the general public was extremely limited. The late fifties saw a number of firms and individuals enter the market place in a competitive spirit, with a resulting increase in quantity and variety as well as quality. It is hard to determine exactly the catalyst which brought this about, but if cornered and pressed for an answer, I'd probably attribute it to nostalgia, an appreciation of the art of the film, a new form of entertainment for the younger generation, the unusual flavor of the rediscovered—all factors which appear to be involved in contributing to the rapid growth of a hobby which only 25 years ago belonged to only a few.

FUTURE PROSPECTS

Combining a love for silent movies with a shrewd sense of a trend for the future, farsighted businessmen have devoted their efforts to locating, reproducing, and marketing the classics, thus putting the hobby within the reach of many who would otherwise be unable to enjoy this particular pastime. The work of these companies and individuals has spurred the development of new and improved reproduction techniques which allow today's collector to purchase a 16mm print that compares quite favorably with the 35mm original from which it was made. In many cases, it is actually possible to improve upon the condition of the print from which copies are to be made by the use of new scratch-filtering processes.

Without the surface scratches which are invariably present on the well worn 35mm original, the resulting 16mm print reduces eyestrain

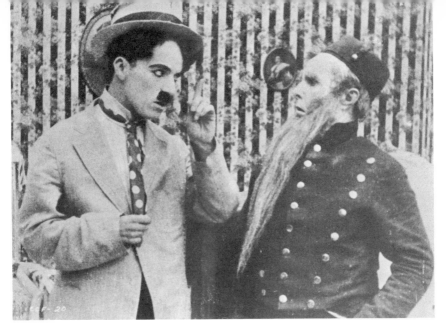

Fig. 3-1. The majority of Charlie Chaplin's comedies are available to collectors.

and enhances the enjoyment of viewing. Present-day copying techniques can be so good that duplicates of many films of a half century ago and earlier appear to have been photographed just yesterday. Unfortunately, this is not always the case for a variety of reasons which we will examine shortly, but the prospects for the future indicate that tremendous strides are still forthcoming, especially in the 8mm area.

SHORT SUBJECTS

The wide variety of short subjects being marketed today—comedies, serials, newsreels, and dramas—represent both the major Hollywood producers and their smaller competitors. For example, most of Charlie Chaplin's early films are available, as are the majority of the Laurel and Hardy comedies. At the same time, the collector can also acquire obscure

Fig. 3-2. You can easily own many of the films of Laurel and Hardy, the beloved comedy team of the twenties.

comedies starring equally obscure comedians such as Bobbie Bolder and Billy Bletcher. Although *The Perils of Pauline* remains the most famous serial or chapter play ever produced, collectors can also obtain chapters from *The Woman in Grey, The Trail of the Octopus,* and *The Indians Are Coming.* The early dramas of Mary Pickford vie for attention with the short western stories of Tom Mix, William S. Hart, and Bronco Billy Anderson.

Fig. 3-3a. No western star has ever equalled the fame of William S. Hart. . .

Fig. 3-3b. But Tom Mix came close. Films of both men are popular collectors' items today.

FEATURES

Longer subjects are becoming increasingly prominent on the market, as the classic films of Rudolph Valentino, Buster Keaton, and Douglas Fairbanks (always great favorites) compete with those of D. W. Griffith, William S. Hart, and Lon Chaney for the collector's attention. Although many of these features represent those major milestones in movie history which are no longer protected by copyright, the trend is now toward the lesser known but equally entertaining features of Johnny Hines, Fred Thomson, Richard Talmadge, and others. All have their place in the development of the cinema as both an art and entertainment form, but because many of these films have not been seen by critics or the general public for several decades, their reputations are not as glamorous today.

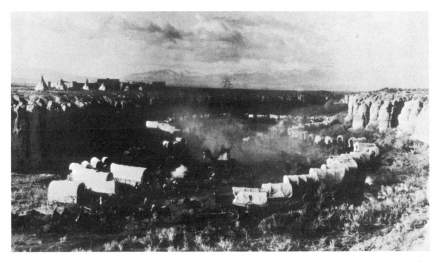

Fig. 3-4a, b. The sweep and grandeur of **The Covered Wagon** has made this 1923 film a long-coveted collectors' classic and is available in a five-reel Kodascope version.

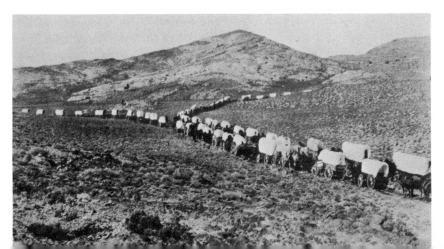

Consider for example the case of *The Virginian,* a 1923 Preferred Picture which starred Kenneth Harlan and Florence Vidor. Released just a few months after Paramount's *The Covered Wagon,* this faithful rendering of Owen Wister's classic novel failed to catch the public's attention and quietly faded into the background of cinema history. Although *The Covered Wagon* consisted of a rather cliché-ridden 10 reels, its story of the Oregon Trail was one of epic proportions, and good use of the camera captured the sweeping panorama and grandeur inherent in the western trek of the pioneers. *The Virginian* was a more inward-directed film, examining the relationship of a man and his code of honor to those around him. As such, the pictorial sweep and splendor were missing from a film which has stood the test of time considerably better than the more publicized *The Covered Wagon.* Both films are now available to the collector; *The Virginian* in its complete form and a Kodascope recut version of *The Covered Wagon* in five reels.

A LARGE AND VARIED CHOICE

All this reveals that among the possibilities which a collector may consider, a sufficient variety is now available to occupy the attention and satisfy the majority of interests common to collectors. The quantity of films available is now expanding rapidly in a market which seems to be far from the saturation point. As a matter of fact, the beginning collector is likely to be slightly overwhelmed by all that is offered to him, and one of his first and hardest decisions will concern the content of his collection. Will he try to collect all of the classics available to him or just a select few? How will he choose those films which will be most enjoyable from among the ever increasing number of offerings?

APPROACHES FOR THE BEGINNING COLLECTOR

Although it is almost impossible for the average beginner to attempt a complete collection of all that is presently available, there are a few guidelines which he can follow to help him answer these questions. At the time of this writing, it would require a financial investment of about $750 monthly to acquire everything available and to keep up with the new releases. The problems of filing and storing the films would occupy so much time that the collection would become just that—a collection—without opportunities for utilization. The collector would quickly find himself in the new role of an amateur film archivist, hard-pressed to pay the rent

on his storage vault. With this demanding need for selectivity in mind, the interested collector should consider the following factors: (1) finances, (2) interests, (3) available time, and (4) purpose.

Finances

Although many collectors would like to devote all of their extra income to the advancement of their hobby, such behavior is usually the exception rather than the rule. The most reasonable approach requires the establishment of a weekly or monthly budget, setting aside the money for those purchases you decide to make. How much to budget is a question that can only be answered by the financial status you enjoy. Some collectors set aside the money and then survey the market to decide how it will be spent. Others plan on purchasing a certain number of films each year and save toward that end.

The amount you can afford to spend will determine to a great extent the type of collection you will acquire. If you can only buy a reel each month, you will probably decide to concentrate on short subjects for variety. Buying only one or two features a year is a very difficult way to

Fig. 3-5. Believe it or not, these swim suits worn by Mack Sennett's "Bathing Beauties" were scandalous in 1918, the year **His Wife's Friend** was produced. Many of the Sennett and Keystone Comedies are available to collectors.

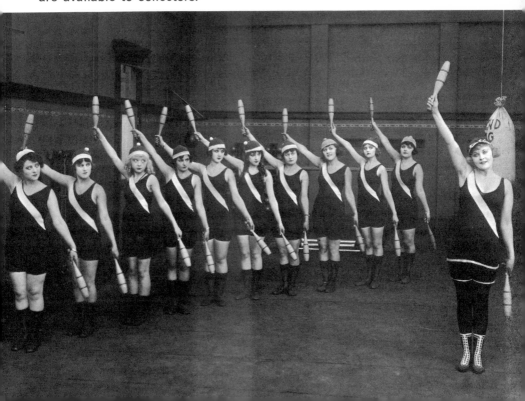

enjoy your hobby. The ability to buy two or three reels monthly will allow you to mix features with short subjects, gaining a measure of variety in both subject matter and film length at the same time.

Some of the major distributors now operate monthly charge accounts for the convenience of their customers and even offer long term credit plans similar to those of department stores. Careful use of one of these credit arrangements can assure you of the means of purchasing long sought films which appear at a time when your hobby budget would not otherwise accommodate such a major purchase.

Interests .

A quick look at the types of films available should help the beginning collector narrow his desired purchases to those he can afford. There are several directions the hobby may take.

Topical

Special interests or other hobbies are often related to films in the topical collection. Railroad fans are likely to be most interested in those classic films with a railroading story for a background; old car *aficionados* will probably lean toward films displaying automobiles. This type of collection remains small and by its very nature is easy to handle and inexpensive to maintain. Such a collection might contain films like the following, all representative of an interest in railroading:

Perils of the Rails and *Webs of Steel,* 5 reels each. Helen Holmes in the types of railroad stories with which her name became synonymous during the silent period—lots of action and iron horses.

Transcontinental Limited, 6 reels. Johnny Walker in a gripping railroad story climaxed by a runaway train.

Chasing Choo Choos, 2 reels. A portion from a Monte Banks feature comedy which combines thrills and miniatures in a lively story.

The General, 6 reels. Buster Keaton's version of the Civil War.

The Hazards of Helen, 1 reel each. Several chapters available from the 119 made in this most famous of all railroad series.

The Iron Mule, 1 reel. Al St. John's comedy parody of John Ford's very popular feature of 1923, *The Iron Horse.*

The Great Train Robbery, 1 reel. The first American story film.

100 Years of Railroad Development, ½ reel. A compilation of clips tracing the history of railroading.

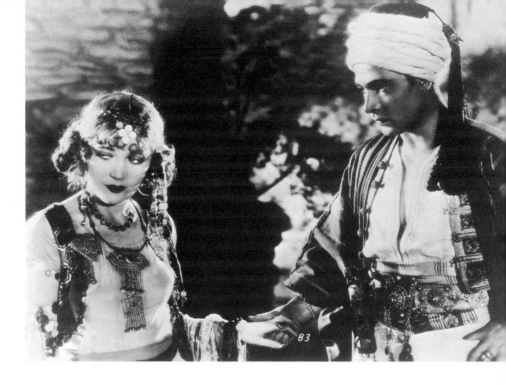

Figs. 3-6a, b. Valentino was not only a great screen lover but a fearless fighter as well, and his films contained more action than love scenes.

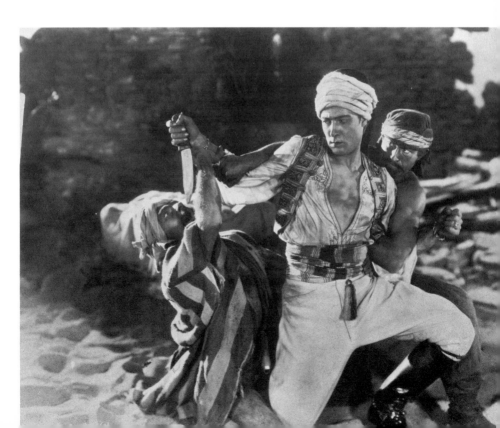

Personality

Other collectors are only entranced by the work of a few screen personalities and thus limit their collecting efforts to the available films of personal favorites. This is another special interest which, like the topical collection, tends to remain small and inexpensive by its very nature. Any collector interested in Rudolph Valentino would probably have at least the following films in his collection:

The Son of the Sheik, 7 reels. Valentino's final and most popular film, released after his death.

The Eagle, 8 reels. Valentino and Czarist Russia.

Blood and Sand, 6 reels. Valentino as a famed matador with woman problems.

Eyes of Youth, 8 reels. Valentino in a supporting role with Clara Kimball Young before he rose to stardom in *The Four Horsemen of the Apocalypse.*

Valentino, His Life and Times, 1 reel. A compilation of clips from his films which attempts to explain the appeal of this great screen lover.

Major Milestones

Another easy collection to put together contains those available films which critics and the public have agreed upon as representative milestones in the development of the cinema as both an art and an entertainment form. However, this type tends to be a good deal more expensive than the topical or personality collection. The following films would belong in any collection of this kind:

The Birth of a Nation, 12 reels. The legendary film which greatly influenced the industry and brought storms of protest from civil rights groups; Thomas Dixon's interpretation of the Civil War and Reconstruction (as filmed by D. W. Griffith); and one of the top money-makers in cinema history.

The Covered Wagon, 5 reels. A Kodascope recut of the epic story of the Oregon Trail, told in a sweeping panorama of plains, mountains, and Indians.

The Cabinet of Dr. Caligari, 5 reels. A German film of 1919 which introduced American movie makers to surrealism on the screen and influenced style greatly during the twenties.

Dr. Jekyll and Mr. Hyde, 6 reels. A tremendous acting performance by John Barrymore in a classic story. A second version is also available, starring Sheldon Lewis.

Gertie the Dinosaur, 1 reel. The first successful cartoon.

The Great Train Robbery, 1 reel. The first American story film. Rather primitive today, its impact on the public in 1903 was immense, and it is often considered to have been the impetus for the development of the entire American motion picture industry.

The Hunchback of Notre Dame, 10 reels. Lon Chaney's first horror masterpiece, notable for his unbelievably fine make-up artistry as well as his sensitive performance on-camera.

Intolerance, 13 reels. Four parallel stories forming D. W. Griffith's answer to the criticism of *The Birth of a Nation,* a critical success and financial failure.

Fig. 3-7. Lon Chaney won praise for his makeup and sensitive portrayal of **The Hunchback of Notre Dame.** Subsequent remakes of this film have failed to capture the power and intensity of Chaney's performance.

Judith of Bethulia, 4 reels. A Biblical story and Griffith's first feature film.

The Perils of Pauline, 2 reels each. Several chapters are available. The third serial made, this 1914 cliff-hanger elevated Pearl White to stardom and became a legend.

The Phantom of the Opera, 7 reels. Lon Chaney's second horror masterpiece. The remakes of this film have failed to equal the power of the original.

Ten Days That Shook the World, 7 reels. Sergei Eisenstein's classic story of the violent revolution in Russia, acclaimed for its advanced techniques.

Tillie's Punctured Romance, 5 reels. Mack Sennett's first feature comedy —contains Chaplin and almost all of the famed Keystone players.

The Tramp, 2 reels. Chaplin's famous little fellow in the type of story which made him a living legend.

Way Down East, 10 reels. A tear-jerking melodrama by Griffith which typifies the Victorian mind of this master director; still interesting and enthralling today.

The Lost World, 5 reels. A Kodascope recut of the granddaddy of the great monster pictures. Its technical achievements were far ahead of the times, although the story was rather trite.

Fig. 3-8. Lillian Gish's moving performance in **Way Down East** still brings tears to the eyes.

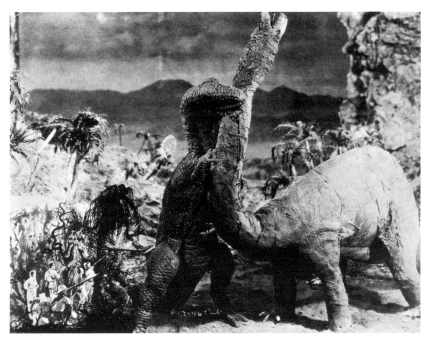

Fig. 3-9. One of the big hits of 1925, **The Lost World** retains its fascination for collectors today. The spectacular special effects of Willis O'Brien reversed the order of things and made the tiny lifelike monsters many times the size of Wallace Beery, Lewis Stone, and Bessie Love.

Representative

Eventually, this becomes a well rounded basic collection which represents various stars and topics and usually includes a balance of one- and two-reel comedies, serials, newsreels, and features of varying lengths. As its size is practically unlimited, the representative collection can easily contain any of the other types. Started with a minimum of cash outlay, it can be expanded as time and money allow.

Generic

This type of collection revolves around the particular kind of film you are interested in. Some collectors are only fond of comedy short subjects, whereas others allow nothing but features to decorate their film storage

area. I personally became interested in the silent serial and for a long time limited my collecting interests to this single area. The size of such a collection depends upon your particular area of interest. For example, silent serial material is relatively scarce compared to the number of comedy short subjects which are available.

Available Time

The spare moments you have to indulge in this new hobby should be carefully considered before you formulate a plan for collecting. Too little time to manage a major milestone or representative collection may mean that you are undertaking too large a project which will eventually have to be put aside for other interests. If this is the case, it would be wise to begin with a topical or personality collection, expanding in one or more directions as more time becomes available to you.

Fig. 3-10. Many comedians failed to achieve the fame of a Chaplin or Keaton, but like Billy Franey's paperhanging, their routines are still funny today.

Purpose

Are you collecting for personal enjoyment or do you plan to put your hobby to work? The smaller type of collection will provide you with the enjoyment you seek but probably will not suffice if you plan to exhibit your films for civic or social organizations. Since the smaller collections can serve as a nucleus for expansion should you decide at a later date to share your hobby with others, it may not be practical at the outset to aim your collecting ambitions too high. Starting with a minimal investment will allow you to investigate this new hobby fully and also give you a chance to decide exactly what you wish to do with it and how far you want to, or can afford to, carry your collecting ambitions.

ORIGINS OF CLASSIC FILMS

Having considered the various approaches to beginning a collection, you are probably curious as to where classic films can be obtained. A listing of reputable distributors will be found in Appendix I; send a postcard to each requesting copies of their current catalogs. Most distributors will keep your name on their mailing lists for six months, even if you do not purchase immediately, which should provide you with ample time to survey the variety of films available and establish the direction in which your collection will grow. Where do the distributors acquire their films from which prints are made for sale? For that answer, let's step back into history for a moment and examine the circumstances surrounding most of the classic films available today.

Theatrical Exchanges

During the twenties and early thirties, many theatrical exchanges, the distributors of films to theaters, went out of business and their stock was either given away or junked. Thus, countless 35mm prints in good, bad, or indifferent condition fell into the hands of interested private collectors, but, unfortunately, many more were destroyed forever. Of those prints which did survive in the private collections, many are being made available in 8mm and 16mm form today.

Film Rental Libraries

Film rental libraries of the same period possessed 16mm reduction prints of high quality, reproduced optically from the 35mm master negatives. For about a decade after 16mm was introduced, from 1925 to 1935,

Fig. 3-11. Cross-eyed Ben Turpin never fails to bring laughs.

Fig. 3-12. Collectors are especially fond of **Our Gang.**

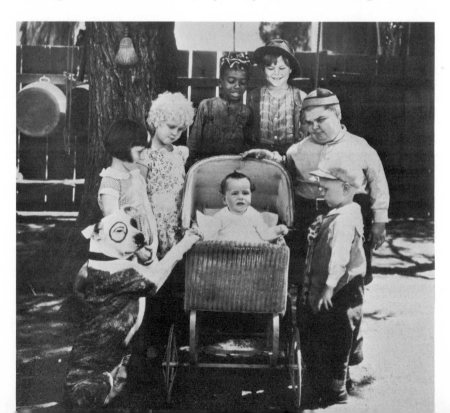

Eastman Kodak operated Kodascope libraries in various parts of the country. Kodak leased negatives of fine-grain prints from a variety of Hollywood producers and made superb amber-tinted prints for rental purposes, first in 16mm and later in 8mm. All of the features used for Kodascope prints were professionally edited into five-reel versions for uniformity, a procedure which improved some of the films considerably. Bell & Howell's Filmosound Libraries functioned in a manner similar to Kodak's, for both operated with the subtle intent of selling more of their new 16mm projectors by making a greater number of films available for owners of home projectors. When 16mm sound films gradually caught on in the mid-thirties, the old silent amber prints were discontinued and many found their way into the hands of collectors as the libraries were closed. These often prove to be quite satisfactory preprint material for 8mm copies.

Private Individuals and Theaters

From roughly 1910 through the early thirties, many individuals operated traveling theaters in the rural areas of the nation. When these people left the business or retired, their films and equipment were stored in attics and barns to be neglected and forgotten over the subsequent years. These films are gradually coming to light and reaching the hands of interested parties who research and reproduce them for the collectors' market.

In the heyday of the silent film, small town theaters always kept spare films on hand in case the express delivery was late with their new show. Stored beneath the projection booth of the theater, the spare show was often forgotten by both the exchange which had provided it and the theater owner who never had use for it. There the films remained until television forced many of the rural theaters to close in the fifties. When the structures were renovated to serve as supermarkets or discount department stores, the films were rediscovered, often finding their way into the hands of interested parties, who preserved them.

Hollywood Studios

These three major sources have been supplemented in recent years by a few of the Hollywood studios and distributors who have licensed some of the small number of remaining silent films in their vaults to the major firms dealing in the reproduction and sale of 8mm and 16mm prints to collectors. Blackhawk Films has drawn on the estate of D. W. Griffith

through Sterling-Killiam and the now defunct Hal Roach studio in this manner, whereas United Artists has made available some of the more desirable First National features of the late twenties through its subsidiary, UA-8. Unfortunately, many of the silent negatives which have survived the numerous vault fires and other hazards of storage have deteriorated to the point where it is no longer possible to reproduce them. The major studios have seen no financial advantage in attempting to preserve the remaining negatives; thus, they too wait for the inevitable deterioration to set in.

COLLECTING ON A SHOESTRING

Since the number of classic film collectors has increased rapidly over the past decade, the supply and demand situation has created a market for used classic films. Here is one way in which the beginning collector can really cut the costs of his desires to a minimum. Used Standard 8mm prints cost $2 to $4 per reel or about half the price of brand-new prints; used 16mm films range from one-third to one-half of new prices, depending upon how much use they have seen and whether they are commercially produced prints or home dupes made by amateurs. Some of the distributors now handle used prints, but private collectors still account for the bulk which appear for sale.

WHAT TO LOOK FOR

When a used print is advertised for sale, it has usually proved to be of limited interest to its owner. Such a film is quite often in mint condition when offered for resale. However, especially in the 16mm field, prints often appear for sale which really merit the term "used"—the titles are missing, the sprocket holes are torn or broken, and numerous or poorly made splices abound. The buyer also stands a reasonable chance of getting someone's homemade dupe if he deals in 16mm. Such prints are usually out of focus and of poor contrast, making it difficult or impossible to distinguish much more than the difference between black and white. This sad circumstance is not limited to 16mm, but since most who duplicate at home prefer to work in the larger size (after all, they have to be able to see what they are duplicating), homemade prints seldom appear in 8mm.

HOW TO BUY OR TRADE USED PRINTS

As in the purchase of a secondhand automobile, take nothing for granted when offered a bargain buy on used prints, unless you personally know the owner. If the owner is not misrepresenting his film, you will be able to work out a mutual agreement without difficulty. If the feature print is very expensive or if the negotiations are between strangers quite a distance apart, and the Post Office must be relied upon to consummate a trade or purchase, it is not unreasonable to offer and/or ask for a deposit to show good faith. Future dealings between parties will tend to be quite informal because a friendly atmosphere springs up quickly between classic film collectors once they have become acquainted.

Should you agree to purchase a used print from a private party, do so only after receiving a full description in writing of the condition of the film, along with a guarantee to refund your money or return your trade if the print does not live up to the description. In the case of a trade, be certain to give him the same assurances. Learning which distributor supplied the print in question can help to remove much of the anguish that might be connected with the acquisition of a used print. This information will tell you immediately the approximate range of quality you can expect, since once you have sampled the wares of different distributors, you will have a fairly good idea of what their product is like.

Fig. 3-13. Obscure comics like Bobby Dunn are also well represented in the available films which collectors can acquire.

When you receive the film, be certain to inspect it first by hand before running it through your projector. Check for broken or torn sprocket holes and poor splices or other physical defects which could cause trouble in the projector and possibly ruin the print. Correct any such defects (and if you should decide not to buy it, don't forget to inform the owner of the repairs you made and why) and then project it to check the print quality against the description before making a final decision. Chances are good that if you play the game fairly, so will the other fellow. But human nature being what it is, collectors should enter trades or purchases by mail with an open eye. It is sad, but when a hobby grows as large as classic film collection has, there are individuals who prey upon their fellow collectors in a highly unethical manner. A few of the more exotic frauds are discussed below.

FRAUDS

Beware of the collector who claims to have a print of a much desired film in his possession which he wishes to sell, usually at an exorbitant price. He may spice the offer a little by claiming ownership of a print which is still under copyright, thus removing the deal from the light of day and putting it in the category of an "under the counter" sale. He will request that you send one-third to one-half of his asking price as a show of good faith, upon receipt of which he will send the film on a money back approval basis. No film ever arrives, but your deposit check has cleared his bank long before this fact becomes apparent. This fraud is difficult to spot sometimes, as the show of good faith is not an unreasonable request. The key here is the desirability of the offered print.

Offers to let you in on a bonanza go something like this—you are contacted by a "collector" who has just located a cache of old films (all in perfect condition) in some out of the way place. He needs a particular sum to part the local rubes from this treasure. If you will contribute 50 per cent, he guarantees that you will participate in the financial windfall which is bound to result when news of this discovery is made known to other collectors who will eagerly pay fantastic sums to obtain these rare items. Kiss your contribution goodbye before sending it; there are no such pots of gold at the end of the rainbow.

The collector who desires to "share" his collection with others will send you a list of his supposed holdings and offer to trade films on a temporary basis, suggesting that in this way you can view each other's collection at no risk. Along with a request for one of his films, he will ask

you to send a similar listing of your collection so that he may select a particular print which interests him. He usually asks that this arrangement be kept quiet since he has so many "rare and desirable" prints in his collection. Sounds reasonable, but if you turn out to be the lucky "chosen one" and fall for it, you are likely to lose your print. A variation of this calls for your new "friend" to write back with the sad news that your collection is ordinary, but he will still keep his word to you if you send a cash deposit, which will be returned when he receives the print back from you. After your cash has been deposited in his account, don't expect to see either the film or the money again.

If you should be victimized by one of the above schemes, or some variation thereof, by all means contact the Post Office, as it is a federal offense to use the mails to defraud. At the same time, contact *The Classic Film Collector*. This paper operates a "Collector's Court" as a service to its readers. Your complaint will be thoroughly investigated, and an effort will be made to help you gain satisfaction. If the other party refuses to cooperate, he risks having his name published in the paper as a warning to other collectors not to deal with him. *The Classic Film Collector* was established by editor Samuel Rubin to bring "integrity to the collecting field," and Mr. Rubin feels very strongly about this particular point.

Fig. 3-14. Richard Barthelmess as the Chinese anti-hero in Griffith's **Broken Blossoms,** another classic film available to collectors.

RENT BEFORE BUYING

An excellent way to avoid buying a film which has been oversold to you (either by reputation or description) is to join one of the rental plans offered by some distributors. For a mere 50¢ or so per reel, you can enjoy all the films you wish to see. For this inexpensive fee, you can easily check on the quality and story content of the film to see if it really belongs in your collection, rather than spending cash for a print, sight unseen. This is especially helpful in decisions involving expensive feature-length films.

Often these rental facilities will also sell used prints at a substantial reduction in cost—you merely keep the film and return a check for the used price minus your rental fee. For the beginner who finds it financially impossible to buy all of the films he would like, renting also has the advantage of letting him see many different films at a low cost. It is also advantageous for those collectors who are not quite certain of the direction in which they wish to start their purchases.

ABRIDGEMENTS AND COMPILATIONS

Another way to hold down costs while building a sizable collection is to take advantage of the numerous abridged films available. By this, I mean shortened versions which have had extraneous material or subplots cut out to "tighten" the overall dramatic or comic effect of the film. This particular issue has set off heated discussions among collectors, for there are two schools of thought regarding edited films.

The Purist Position

The purist holds that to cut any classic film in any way is a sacrilege. This collector keeps a close eye on the length of the films he is considering and tries to ascertain whether they are the same length as were the originals. He also gets upset if the main and subtitles are not original or at least a close approximation of the originals. This attitude has several different degrees of rigidity in application, but all purists fail to take into account the fact that the film in question may have decomposed to a point where only editing of some form could help preserve its continuity. The purist also refuses to consider the question of professional editing.

The Realist

A more prevalent and realistic attitude holds that many classic films contain subplots and other material which can very well be removed without destroying the value of the film. If done by a professional who knows his business, such editing can even improve certain films and helps to hold the costs down for the collector. Many of the classic films were recut after their initial theatrical preview had exposed their weak spots. Over 700 feet were removed from the *The Virginian* of 1923 by its producer after a sneak preview, reducing the total 35mm footage from 8,010 to 7,280 feet. Unlike the editing done today to fit a feature film into a television spot, in which a portion of the film is too often just cut out for replacement by a commercial, editing of this nature was done to improve the film while maintaining its story continuity.

Abridgements Have Advantages

Abridged versions do cost less, and unless you become so devoted to classic films that you accept the purist point of view, they deserve consideration. For example, the five-reel Keystone feature of 1915, *Tillie's Punctured Romance,* is available in Standard 8mm for about $30; a three-reel version retaining both the flavor and the story costs only about $18. Almost two reels have been removed from the original and, in my opinion, the editing makes it a far more interesting film as many sequences in the original tended to side-step the basic plot, slowing down the action.

The Omnibus Film

Another form of abridgement which merits consideration is the compilation or omnibus film such as *The Saga of William S. Hart* or *Valentino, Idol of the Jazz Age.* These films use segments from several of the stars' films and often trace their careers quite nicely. Usually done in one- or two-reel lengths by professional editors who select the proper segments to tell the desired story, the omnibus film has several advantages besides low cost which interested collectors should consider.

Such compilations serve as a preview to a particular star's work. Even if you should decide to purchase all of his available films after seeing the omnibus, it still serves as a good recap or abstract of what was probably a lengthy career. In some cases, the compilation is a collector's version of a television documentary and contains sequences which no collector could legally obtain otherwise. Since the films used to compile such an

omnibus are sometimes still protected by copyright, only the TV producer could get permission to reproduce and use such footage. Under these circumstances, the omnibus or compilation film becomes an even more desirable item to own.

During the twenties and thirties, Hollywood studios produced several series of *Screen Snapshots, Movie Milestones,* and *Screen Souvenirs.* These potpourri reels, which hold a great deal of interest for the collector, are available today at a relatively low cost for the variety they provide. Often such films are the only sources of footage on features and stars otherwise not obtainable. *Movie Milestones #1* contains, for example, scenes from Valentino's *Blood and Sand,* Lon Chaney's *The Miracle Man,* Ronald Colman's *Beau Geste,* and glimpses from *The Covered Wagon,* probably the most famous of the epic westerns. All four sequences are from extremely desirable films from the collector's viewpoint, but only two are available for his purchase in complete form. Variety reels such as the *Movie Milestones* series can serve the collector in many ways—as audience teasers, previews of coming attractions—factors which require their consideration by any collector.

Beginning collectors should approach these abridged films with open minds, determining if they can add significantly to their collections. Should cost prove to be a factor, such films should be considered very carefully since they can help stretch an otherwise limited budget to cover a good deal more ground, sacrificing only the collector's ability to make the statement, "I have the complete, uncut version of"

CHAPTER IV
FILM REPRODUCTION AND SIZE

COPYRIGHT CONSIDERATIONS

Of necessity, copyright considerations become a concern to those who reproduce films. When dealing with reputable distributors, there is little cause for the collector to worry about the legality of a print. Such companies thoroughly investigate the copyright status of any film before they spend time and money to reproduce and market it. But at times, collectors will encounter other dealers whose scruples are not as great. Often, films of such a prized nature are offered under the counter that even a conscientious collector finds it difficult to resist the temptation to own a print he has long desired or one which other collectors do not have, even if it is illegal.

What Is a Copyright?

A copyright is a legal guarantee of the exclusive right to the publication, production, or sale of the rights to a literary, musical, dramatic, or artistic work, granted by law in the United States for a period of 28 years, with the option for renewal of one additional term of 28 years, or a maximum of 56 years. Until 1912 there were no specific provisions for protecting motion pictures other than to copyright them as photographs. Early manufacturers and producers took advantage of this loose protection to duplicate and sell as their own the films made by their rivals, creating such confusion that Congress finally established a separate copyright for motion pictures.

Copyright Expiration

Just before the initial 28-year copyright is due to expire, the owner has the option to renew it for one additional 28-year term. If this renewal option is not exercised, the protection ceases and the film becomes public domain. Should renewal be exercised, protection granted is thereby extended to a total of 56 years, after which the film becomes public property.

THE ECONOMICS OF FILM REPRODUCTION

Suppose that you have acquired a 35mm print which is no longer under copyright protection and would like to have an 8mm or 16mm reduction print made for use in your collection. Perhaps the most practical way to handle this situation would be to contact some of the distributors listed in Appendix I. Describe the film you have as fully as possible in terms of its length, physical condition, and content. If the main titles are intact, copy the information which they contain and forward this to the distributor. If the film appears to have sufficient potential for the general market, he will accept your offer to copy it on the condition that the print be in reproducible shape. In addition to a small cash payment for the privilege of reproducing your 35mm film, the distributor will provide you with your choice of an 8mm or 16mm reduction print.

Should the distributor feel the film will not at least reimburse his costs or should you decide not to share your find with the collectors' market, you can contact photographic laboratories which are equipped to make reduction prints from 35mm films. Unfortunately, if this is your only alternative, the costs can be prohibitive. Investigate the commercial laboratories carefully; many charge by the original foot for such work. One reel of 35mm film contains approximately 1,000 feet of film, which will result in a reduction print of either 200 feet (8mm) or 400 feet (16mm). If the lab charges by the 35mm foot, a fee usually in the neighborhood of $100 per 35mm reel (figured at 10¢ per foot) is levied.

For this price you will receive a single reduction print made on reversal film stock, similar to the black-and-white film used in home movie cameras. The quality will not be as good as that of a print made from a carefully prepared reduction negative, but for this charge you can expect and should demand a reasonably good result, depending upon the quality of your original. If the lab obtained a large enough order of prints from your film, it would make a negative and contact prints at a price per print considerably less than the $100 for a single print.

Try to work through the classic film distributors if at all possible since the quality of the print you receive will most often be much better than you could expect if you invested your own money in a single print. Should portions of your 35mm print be scratched or in the initial stages of decomposition, you can expect that the distributor will do his best to restore the film technically as closely as possible to its original condition; commercial labs, preparing only one or two prints for you, will undertake such restorative work only for an additional (and exorbitant) fee.

FILM QUALITY

Quality is a relative consideration, and each collector must establish that level below which he will consider a print to be unacceptable. Although everybody looks for sharp, clear, and sparkling images, no realistic collector should expect to get theater quality from his 8mm or 16mm prints. Some understanding of the many inhibiting factors at work should be a part of every collector's knowledge so that he can appreciate the reasons for the many variations in quality he will encounter.

Preprint Material

Every time a reduction print is made or a duplicate print is struck, quality becomes a concern regardless of other considerations. Of course, the best preprint material is the original 35mm negative, but comparatively few are still in existence. Next comes the use of a 35mm master positive or an original release print in mint condition. (See Fig. 4-1.) Preprint material other than these three sources usually contains some degree of imperfection, which is invariably magnified in smaller prints.

Fig. 4-1. Use of the master negative or a good release print will insure quality and sharpness, as in this scene taken from "The Veiled Priestess," Chapter #4 of Kalem's **The Ventures of Marguerite.**

(See Figs. 4-2a and b.) Well-worn 35mm release prints are often the only possible source, and the emulsion and surface scratches on the film tend to give the projected picture the appearance of rain. To minimize these scratches, a freon–xylene bath just before printing is now used by some laboratories. This process fills the surface scratches with a fluid having the same refractive index as the objectionable scratches, rendering them invisible in the new prints.

Fig. 4-2. Poor preprint material or amateur attempts to make a duplicate result in a contrasty blur which appears on screen like these:

a. Elmo Lincoln in his role as the original "Tarzan of the Apes."

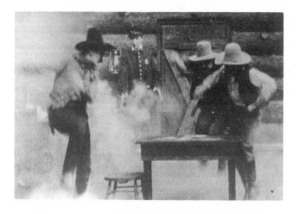

b. George Ovey in one of his "Jerry" comedies.

The 35mm films are reduced to 8mm or 16mm by use of an optical printer, a mechanism which amounts to a 35mm projector coupled to an 8mm or 16mm camera mounted on a lathe-type bed, with the optical centers of their lens systems geometrically in line. The 8mm or 16mm portion of the printer can contain either fine-grain duplicating negative film or reversal stock. The former produces a new negative on the smaller film stock from which any number of same size prints can be made by contact printing; the latter is processed just as home movies are, resulting in only a single print. This use of reversal film is less desirable. Three prints of the same subject made in this manner are likely to vary in density and contrast from each other, but reversal film is often used when only a handful of prints are needed. Making a new negative on the smaller film stock is the best way to retain the quality of the original, as subsequent prints will be uniform in quality. Remember that each time a film is run through either a projector or a printer, it is subjected to further scratching from contact with dust, dirt, and metal parts.

If no 35mm print is available, duplicates can be struck from some 16mm prints; rarely does the quality prove to be more than just acceptable. Attempts to duplicate 8mm prints are occasionally made by unscrupulous individuals (yes, this hobby has its share too), but because of the extremely small image, the results are seldom worth the effort. In the final analysis, reduction prints made from new negatives by professional laboratories are always superior to reversal prints. Although many amateurs have obtained their own inexpensive duplicators, home attempts to strike a dupe from another film are usually poor. Unfortunately, the results of their unhappy efforts may be offered for sale to unwary collectors. Let the buyer beware!

Graininess and Other Problems

Another factor to consider in the ultimate quality of reduction prints is the physical characteristics of the image. Photography depends upon the reaction of minute grains of silver to light. As the size of the image is reduced, it is composed of fewer particles of silver to do the work, leading to a quality we call *graininess*. This quality destroys shadow and highlight gradation, resulting in a reduction in the clarity of the screen image. Graininess is definitely an inhibiting factor in reducing a 35mm print to 8mm, a reduction amounting to an end product about 1/24 of the original area.

Additional problems can also arise due to the physical condition of the

original. If the 35mm print is curled, shrunken, or has uneven or broken sprocket holes, the resulting image will contain a sharpness which varies, along with a screen picture which jumps. Since silent films contain slightly larger pictures than present-day sound films, poor or hasty attempts to reproduce prints often lead to off-center titles. This smaller picture area on today's prints is due to the area masked off and occupied by the optical sound track. Current printing equipment contains an aperture mask which conforms to the frame size of a sound film and is thus unable to produce the correctly proportioned reduction from the slightly oversized silent picture. (See Fig. 4-3.) Reduction printing from silent 35mm films requires the replacement of the aperture mask and a careful adjustment of the printing apparatus when new prints or negatives are to be struck. (See Fig. 4-4.) Unfortunately, many labs tend to neglect or overlook this factor.

Fig. 4-3. (Left) Careless reduction printing sometimes results in titles which are cut off on one or both sides. This is caused by the use of an aperture mask in the printer designed for current sound films, which have a picture area slightly smaller than the silent film in order to accommodate the sound track. Fig. 4-4. (Right) Properly made reduction prints will have titles like this, in which all of the picture and writing appears correctly framed and centered.

FILM SIZE

Potential collectors, as well as some who have actually started to collect films, are frequently confused and even dismayed by the four commonly accepted sizes or gauges in which classic films are available—35mm, 16mm, Standard 8mm, and Super 8mm. In determining which is

best for your purposes, let's examine the three related factors of cost, quality, and compatibility to see how they will influence any decision you make.

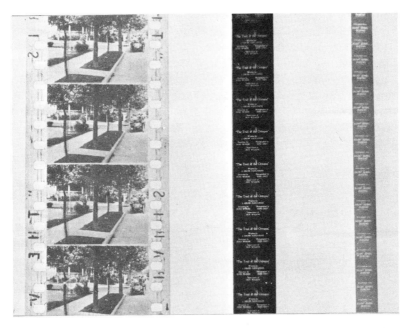

Fig. 4-5. This comparison of the three most popular film sizes— 35mm, 16mm, and Standard 8mm shows the image size of each.

35mm—The Spoiler

The granddaddy of them all, 35mm is the standard theatrical size and the original size of all prints which circulate in other gauges. The collector who decides to concentrate on 35mm is really collecting what amounts to originals and must expect to pay a considerable premium in cost of both films and equipment to obtain this ultimate in quality. He must also consider that, in addition to a greatly varying print cost and a reduced choice of material to collect, many 35mm prints offered by other collectors or located in antique or junk shops (presently, no commercial firms deal in 35mm originals or duplicates—they are a one-of-a-kind proposition) will have to be renovated by a professional lab in order to project them. Others will be useful only for hand viewing, as their physical

69

condition makes projection and to a varying degree reproduction impossible to achieve without further damage to the film. Excessive splices, decomposed footage, and broken, torn, or shrunken sprocket holes are but some of the severe defects which collectors of 35mm prints will encounter.

In some cases, the prints will have to be transferred to other film stock, because the unstable nitrate film base which was used for all silent theatrical prints will certainly have suffered over the years, either from excessive use or from the ravages of time. Nitrate film characteristically decomposes into a fine yellow-brown ash and has a tendency toward brittleness and shrinkage. More and more collectors of 35mm film are converting their prints to a smaller size on a safety film base for the very good reasons of cost, convenience, and storage.

16mm—Expensive

Once the size most popular with collectors, 16mm film possesses quality almost the equal of 35mm for collectors' purposes and more economical in terms of cost and space. Many of the film rental exchanges which operated in the twenties and thirties circulated 16mm reduction prints made from 35mm master negatives, assuring top quality in the resulting prints. Quite a few of these fine-grain reduction prints are still in circulation and can often be used to make reasonably good duplicates. Commercial firms dealing in the collectors' market sell 16mm prints for

Fig. 4-6. All 16mm silent projectors are limited to a one-reel capacity. Projectors like this Keystone have virtually disappeared from the market; most collectors prefer a 16mm sound projector which will also run at silent speed.

between $20 and $25 per 400-foot reel. Since each 16mm reel contains enough film for about 15 minutes of projection time, an hour-length feature will cost in the neighborhood of $100. Excluding the special purpose projectors used in schools and industry, only two 16mm silent machines are still manufactured. Most collectors of 16mm films tend to buy a used 16mm sound projector which will also project at silent speed—a bargain compared with the excessively expensive new silent projectors ($410 and up).

8mm—The Great Boom

Because most collectors initially confine their hobby to their home and are not interested in a large projected picture, there has been a great boom in the Standard 8mm market over the past decade. If you are one of the several million Americans who own a Standard 8mm projector, this size is probably (as our British collector friends say) your cup of tea. You already have an easy to operate, inexpensive machine to project whatever films you buy and no further equipment investment is required at this time. Standard 8mm film is low on the scale of quality when compared with either 16mm or 35mm, but great advances have been made in reproduction techniques during the past five years (more will be coming in the very near future). Unless you require a projected picture larger than four feet in width, Standard 8mm should be quite acceptable. This is especially true when you consider cost, ease of storage, portability, and other factors.

Because each frame or picture on 8mm is only one-fourth the size of a 16mm frame (see Fig. 4-7), twice as many pictures can be placed on the

Fig. 4-7. As shown here, the Standard 8mm picture area is slightly less than one-fourth the size of a 16mm frame; Super 8mm is slightly more than one-fourth the size.

same length of film. In effect, this reduces the size of the reel by one-half, so that 200 feet of Standard 8mm film contains exactly as many frames as 400 feet of 16mm film. Cost is therefore a great deal less—the $20 to $25 16mm film can be purchased in Standard 8mm for between $4 and $7. As every collector wants to maximize his collection for the amount of money spent, this factor alone has made Standard 8mm the most popular size in the field.

Super 8mm—The Challenger

Pioneered by Eastman Kodak, Super 8mm, a recent development in the home movie field, uses the same size film as Standard 8mm but increases the picture area of each individual frame by reducing the size of the sprocket holes used to transport the film through the projector. Super 8mm has caught on rapidly with amateur movie makers because of a persuasive advertising campaign. Commercial suppliers of classic films have started to release versions in this gauge as well as in Standard 8mm and 16mm, at a cost of approximately $1 more than the comparable Standard 8mm reel.

Compatibility

The dilemma of choice raised by the four available film gauges is further compounded by the fact that films available in one size may not necessarily be available in other sizes. Depending upon the cost and quality, the collector is faced with the problem of compatibility if he wishes to collect without restriction of subjects. Distributors of classic films have directed their primary attention toward the 8mm field, and here the problem of compatibility has been solved for the users of Standard and Super 8mm, as most projectors marketed today have dual functions. They will project either film size simply at the turn of a knob or the throw of a switch. But for the person who wishes to collect both 8mm and 16mm, things are not as simple. Bolex once made a convertible projector of high quality which could be used to project either size (see Fig. 4-8), but these machines are found only occasionally on the used equipment market today. Most collectors interested in two or more gauges find it necessary to buy two projectors, as well as two each of most supplemental equipment, such as splicers, editors, and rewinds.

Projectors used with 35mm film and priced within the reach of collectors are found only as used equipment and, in addition to being cumbersome in terms of size and bulk, are difficult to find spare parts for. From

Fig. 4-8. A convertible projector once manufactured by Bolex, the G8-16 was the only machine to accommodate both 8mm and 16mm. The change-over kit included reel spindles, sprockets, film gates, and lenses for each size.

a practical standpoint, cost favors Standard or Super 8mm; quality leans toward 16mm. Compatibility may lead you to adopt whatever film size your present (if any) equipment requires, but each person should weigh these factors along with the availability of the various subjects he is interested in, the amount of space that he can devote to the hobby, and the use to which he will put his collection.

Two Obsolete Sizes

Some collectors seem to be more fascinated by the system than by the films themselves; as a result, two lesser known and now obsolete film sizes have survived. Although prints are no longer made, used ones are

Fig. 4-9. Many of the Pathé comedies of Snub Pollard were marketed in both 9.5mm and 28mm. Here the little Australian comic explains the "Big Idea" which, as all fans know, will only get George Rowe into trouble.

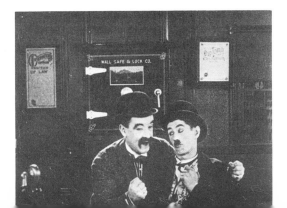

still available, and both 28mm and 9.5mm have their proponents, even though the gauges are now referred to as "living corpses." The 28mm film appeared just before World War I when Pathé, a French company, pioneered the size as a means of bringing movies into the home and school as the phonograph had done for musical entertainment. Pathé devised a well designed 28mm system with camera, projector, and a wide library of films reproduced from its own theatrical releases and at a later date those of other producers. Quite a few of these prints have survived since they were printed on a cellulose acetate base which does not have the decomposing qualities of nitrate film. Distinguishable from 35mm by their slightly smaller width, 28mm prints also have an unusual sprocket hole arrangement—four holes per picture on one side of the film and one hole per picture on the opposite side—and are usually quite satisfactory preprint material for reduction to 8mm or 16mm.

World War I interrupted the development of 28mm as a home format and in 1922 Pathé engineers brought forth the 9.5mm gauge with sprocket holes on the frame line in the center of the film. This size met with great popularity in Europe until World War II, and a very large number of films were made available in it. With its popularity mainly restricted to Europe (over 80,000 units were reported to have been sold), Pathé even developed an optical sound 9.5mm film, only to have World War II interrupt its business again. After the war the great acceptance of Standard 8mm by the American public, coupled with Europe eagerly seeking to export equipment abroad, sounded the death knell for 9.5mm. But over the years, a surprising number of staunch supporters have rallied to the cause, and in 1956 an English group was formed to preserve the gauge, calling itself the Vintage Film Circle. Equipment and films can still be located in antique and junk shops, in attics, and with other collectors, but the supply in this country grows smaller every year.

CHAPTER V

THE PROJECTOR AND RELATED EQUIPMENT

Motion picture film is best described as a strip of clear, transparent cellulose-acetate, one side of which has an emulsion coating containing light-sensitive silver particles. When this film is exposed to light in a camera and then developed in certain chemicals, the result is a series of pictures, each slightly different from the others. Since the film base is transparent, light can be directed through this strip to project images on the screen. Regardless of size, movie film has at least two distinct elements: individual pictures or frames and a series of perforations along one or both edges. Standard 8mm, Super 8mm, and 16mm sound film utilize only one set of perforations or sprocket holes; 16mm and 35mm silent film use two sets.

Although your films form the nucleus of a collection, they are useless unless you have the necessary equipment with which to project, enjoy, and maintain them. Beginning collectors often try to cut financial corners by skimping on the investment required to buy high quality equipment and as a result gain less than maximum enjoyment from their hobby. The new collector should give very careful consideration to the purchase of his projector, screen, splicer, and editor, paying the price necessary to buy that equipment which will do the best job. The problem is, of course, that the person new to movies and collecting has no way of knowing exactly what he needs. In this section, fundamental considerations are presented to the beginner to help him in this difficult area.

PROJECTORS

This single most important piece of equipment can cost as little as $40 or as much as $2,500, but the collector usually purchases a machine in the

75

$75 to $200 range, avoiding the less expensive models as inadequate for his needs. Exactly what will your needs be? As your collection grows, your investment in film will mount, and your projector should be one that will pamper this investment.

The first consideration should be the quality of the projected picture. Is it sufficiently sharp—bright enough to be easily viewed from a reasonable distance and steady enough to avoid eyestrain? Since there were 137 different models available in 1968, I strongly suggest that you survey the market carefully, exploring especially the following aspects to determine which particular machine will best suit your requirements in terms of the following: basic features; film transport system; light source and optical system; reel capacity; and simplicity of design.

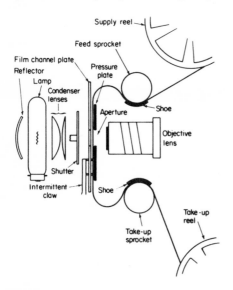

Fig. 5-1. These essential elements will be found in any quality motion picture projector, regardless of film size.

Basic Features

Your projector should have the following features:

Simplified film path. The threading arrangement which carries the film from one reel to another should contain a highly polished, precision-machined metal film gate with a pressure plate that can be removed for cleaning. In order to avoid excessive film wear, the surface over which your film travels should be as smooth as is humanly possible to manufacture. Avoid inexpensive projectors which use plastic or metal-plated materials in this critical area.

Still projection control. Occasions will arise when you will want to study a particular frame on the screen. A clutch or still picture control allows the projection of a single frame and when engaged causes a special heat-absorbing filter or screen to drop automatically into place between the lamp and the film, preventing the now stationary film from damage. (See Fig. 5-2.) Although the introduction of this protective filter reduces the amount of heat reaching the film, it also changes the focus, which will have to be adjusted to study the frame and readjusted once the film is in motion again.

Fig. 5-2. An extreme enlargement of a Standard 8mm frame, showing what happens when the heat-absorbing filter fails to operate correctly while the projector is in the still projection mode. The frame positioned between the light source and the objective lens blisters and burns as a result of the concentrated heat.

Frame control. A necessary feature for enjoyable viewing of your films, the framer allows you to center the picture perfectly on the screen vertically. Depending upon the lab which reproduced the print and the condition of the original film from which it was made, there may be a slight variance in the frame line between sequences. In such a case, a portion of one frame will be cut off and the equivalent amount of another frame will show on the screen at the same time, as shown in Fig. 5-3. Your projector should provide a correction for this eye disturbing situation.

Reverse mode. Unless your projector has a mechanism which allows it to operate in a reverse as well as in a forward direction, you will be unable to view particularly interesting or amusing scenes a second time without stopping the projector, removing the film, manually spooling it back to the point where you think the scene begins, and rethreading the projector. This procedure is slow, cumbersome, and conducive to film damage. Buy a projector with a reverse mode and accomplish the same procedure by flipping a switch or pushing a button.

Variable-speed control. In the early days of the movies, cameras were hand-cranked as were the theater projectors, providing some interesting effects for the audiences. Perhaps to save film, the cameraman might undercrank his camera, that is, slow it down somewhat from the usual speed of 16 frames per second. The projectionist, who might have had a heavy date after the show, was eager to finish work as fast as he could; thus, he cranked the projector faster than normal to hurry the film through. This combination of undercranking the camera and overcranking the projector produced some breathtaking results on-screen, as everything moved with a speed completely out of proportion to reality.

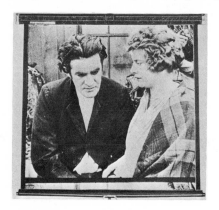

Fig. 5-3. When the projector is out of frame, a portion of one picture is cut off at the top and the frame line shows at the bottom, along with the missing part of the picture. The screen shown here is one of the wall mount variety.

We witness a similar effect today when silent films are shown on television. Photographed in 35mm for a normal running range of 40–70 feet per minute, the old silents are shown on modern sound projectors electrically governed to operate at a speed of 90 feet per minute. This speeds up the action to a ridiculous extent and leaves the viewer shaking his head, muttering to himself that movies are better than ever today after all! Since there was no guarantee in earlier days that any two films would be photographed at the same camera speed, the speed of electrically driven projectors was controlled by a rheostat, which allowed the projectionist to vary the speed deliberately to suit the mood and tempo.

As a collector, you will be acquiring copies of such films. Their conversion from 35mm to 8mm or 16mm in no way affects this speed variation, and your projector should have a rheostat control which allows you to govern the speed at which the film is viewed. Should you decide to use accompanying music on tape at a later date, a variable-speed control is a necessity in order to pace the projector properly with the tape playback. Few projectors of recent manufacture have this feature, and the lack of this control may well set you to thinking about buying a used projector of older vintage. Other benefits of older projectors will become apparent when the purchase of a machine is evaluated on the basis of the remaining considerations.

The Film Transport System

The projector is a device for transporting the film between a light source and an optical system, resulting in a greatly magnified image thrown on a screen, wall, or other surface. In order to do this properly, the projector must have a method of feeding the film from one reel to the other at a constant rate of speed. In operation, this is accomplished best by a motor driven series of sprockets* which engage the small holes along the film edge and move the film at a predetermined rate through the film gate where the intermittent and shutter create the illusion of motion.

A claw like arm connected to a revolving shutter, the intermittent en-

*Sprockets are wheels with teeth on one side, positioned to fit the perforations on the edge of the film. The film is placed over the sprockets and locked into place by clamps or shoes which fit over the sprocket teeth. Roller wheels (sometimes known as stabilizers or snubbers) are often incorporated in the threading path to guide and direct the film along correctly.

gages the film, holds it perfectly still for a fraction of a second, and then releases it while the shutter blocks the light from the screen. The intermittent then swings back into place and grasps another frame of film, repeating the cycle as the shutter revolves and allowing light to reach the screen again. With silent films this cycle is repeated 16 times per second; a speed too fast for the human eye to notice the alternate pictures and blackouts. Because each picture is slightly different from the preceding one, the eyes assume that motion is taking place—the "persistence of vision" theory. Thus, while the sprockets transport the film through the projector at a uniform rate of speed, the intermittent moves the film past the aperture in quick short jerks at the same rate. This combination requires a loop in the film before and after the aperture to allow for the free movement of the film past the aperture without placing undue stress and strain on it.

From this simplified explanation, it becomes apparent that two vital mechanisms of any motion picture projector are the sprockets, which transport the film at a constant speed, and the intermittent, which breaks this constant flow of film into individual pictures to be shown on the screen. Unless the sprockets and intermittent function in proper synchronization, the projected pictures will not be properly aligned one after the other on the screen, producing an effect which leads the eye to believe that the picture is jumping up and down on the screen. Since the eye attempts without success to compensate for the varying placement of the pictures, this annoying situation will cause considerable eyestrain after a short period of viewing.

With 16mm and 35mm projectors, this is no problem, as all manufacturers still abide by this concept of film transport. But some manufacturers of 8mm projectors have attempted to engineer machines without sprockets, relying upon the intermittent to transport the film in addition to performing its own function. Collectors will do well to avoid these types of projectors—they place too much stress on the sprocket holes of the film. When the intermittent is used to pull the film through the machine, it tends to enlarge the sprocket holes slightly after the film has been projected a few times. Enlarged sprocket holes will result in a jumpy picture, and it is also possible for the intermittent claw to rip a considerable number of sprocket holes before the projector can be stopped.

Many current 8mm projectors also thread themselves automatically, a feature which is quite appealing to the fumble-fingered amateur movie

maker but one usually avoided by the serious collector. Automatic threading machines have caused their share of film damage in the past, and should trouble develop, you will want instant access to the film path. You will also need easy access to the film gate and sprockets for cleaning away particles of dirt and lint which accumulate—a feature which many automatic projectors deny you. These particles tend to scratch the film unless periodically removed, and a finely machined and polished film gate is useless if another part of the machine contributes toward film scratching. It is good practice to clean the film gate before each reel is threaded and the sprockets and film path after each showing.

The Light Source and Optical System

The newer projectors do have one advantage over old models—modern light sources such as the quartz iodine and dichroic reflector bulbs produce a somewhat brighter, whiter, and more evenly distributed light than that of the tungsten filament bulbs commonly used in the past. However, it is possible to combine an older projector and a brighter bulb by using socket adapters (see Figs. 5-4a and b) made by Sylvania for

Fig. 5-4. Owners of older projectors can update their equipment by replacing the tungsten filament projection bulb with the newer Tru-Focus lamps by using Sylvania socket adapters. (a) The #390 has the Bell & Howell flange; whereas (b) the #350 fits all medium pre-focus bases. The socket adapter also serves as an extension unit to properly position the new bulb in its correct plane with the film and lens.

Fig. 5-5. The new breed of projectors are largely self-threading models which will use either Standard or Super 8mm by simply turning a knob or flipping a switch. If you decide upon such a projector, be certain to check for ease of cleaning and access to the film in case it breaks. A representative sampling of this type of projector includes (a) Honeywell Elmo 330; (b) Keystone Dual 8; (c) Kodak Instamatic M85; (d) Bolex 18-5 Super; (e) Bolex Super 8mm.

a.

b.

c.

e.

d.

this specific purpose. In this way, some but not all of the new light sources can be used to update an older projector.

The usual optical system consists of a reflector behind the bulb with condensers and a heat absorption filter in front of the bulb to focus the light rays through the aperture and into the objective lens. Bulbs of the Tru-beam, Tru-flector, and dichroic variety contain the reflector hermetically sealed behind the filament inside the bulb. Such lamps are more efficient in the amount of light they deliver to the lens, but beyond this point many projectors are incapable of delivering a picture to the screen acceptable to the collector because their lenses are of such poor quality.

The lens is a very important part of any projector, and unless it has

been carefully designed and manufactured, the best light source and optical system design cannot overcome its deficiency. The majority of poor lenses tend to deliver a picture that is sharp in the center but out of focus toward the edge of the screen. Such lenses can be focused for sharpness at the edge, only to have the center blur. When buying a projector, you should view one of your own films to check both the focusing range and the degree of uniformity in screen sharpness from center to edge. A lens using a field-flattening element will correct the center-to-edge variations in sharpness, giving the sharpest overall picture.

At the same time, check the evenness of light distribution on the screen by placing the projector about 10 feet from a screen in a darkened room. With no film in the machine, turn on the switch and measure the light reflected from the center of the screen by using a photoelectric exposure meter. Then measure the light reflected from the corners. The difference in light distribution should not exceed 50 per cent.

A word or two about zoom lenses seems to be in order here. A zoom lens is one in which the optical elements can be moved by twisting a knurled ring around the front of the lens, changing the effective focal length. This internal movement of the elements changes the size of the picture on the screen, allowing you to produce a picture of different sizes without moving either the screen or the projector. Unfortunately, zoom lenses are especially notorious for producing a soft picture, one whose sharpness falls off rapidly from the center to the edge of the picture. Zoom lenses today are usually attractive to the amateur who would not know a sharp picture if he saw one. For the collector who will be screening films which do not possess absolute sharpness in their images, a zoom lens will not do the job properly.

Reel Capacity

For the collector, the next important consideration is the reel capacity of the projector; that is, how much film will it hold? A reel is defined as 1,000 feet of 35mm, 400 feet of 16mm, and 200 feet of Standard or Super 8mm film (see Table 5-1). The capacity of silent 16mm projectors is only one reel, but 16mm sound projectors can handle up to 2,000 feet (or five reels) spliced together, which provides a longer showing time without stopping to change reels. This greater capacity of 16mm sound machines is another reason why many collectors of that gauge prefer a sound projector, which will also run at silent speed, to the silent projector.

TABLE 5-1

Running Time					
16mm Silent Film			8mm Silent Film		
Ft	Min	Sec	Ft	Min	Sec
1	—	2½	1	—	5
2	—	5	2	—	10
3	—	7½	3	—	15
4	—	10	4	—	20
5	—	12½	5	—	25
10	—	25	10	—	50
15	—	37½	15	1	15
20	—	50	20	1	40
25	1	2½	25	2	5
50	2	5	50	4	10
100	4	10	100	8	20
150	6	15	150	12	30
200	8	20	200	16	40
250	10	25	250	20	50
300	12	30	300	25	0
350	14	35	350	29	10
400	16	40	400	33	20
600	25	0	—	—	—
800	33	20	—	—	—

Most projectors using Standard or Super 8mm are made to accept 400-foot reels, but some of the less expensive projectors are still restricted to a 200-foot reel. A capacity of 400 feet of 8mm film allows collectors of that size to splice together two reels for an uninterrupted showing of up to 32 minutes and is more desirable than one limited to a 200-foot or 16-minute screening time.

USED PROJECTORS

Whether you favor the newer machines with their automatic features or the older ones with their well-earned reputations for dependable service, most collectors do agree that a simple, uncomplicated projector design is most desirable. For this reason, the purchase of older machines on the used market has increased greatly among collectors in the last few

years. Regardless of the appeal of today's automated equipment, many collectors of Standard 8mm and 16mm film feel that it is difficult to surpass the simplicity and reliability of such older projectors as the Bell & Howell 122 series, the Revere 85 and 90 models, and the various Keystone projectors manufactured in the 1950's—all now discontinued from production. The user of Super 8mm film does not have the option of purchasing these old projectors because the film format is only a few years old—its development coincided with the engineering of the newer projection equipment.

a.

b.

Fig. 5-6. Three older standard 8mm projectors remain favorites with collectors of today—(a) Bell & Howell 122LR; (b) Keystone K-108; (c) Revere 85.

c.

With few exceptions, 8mm projectors marketed today are equipped to project either Standard or Super 8mm film at the flick of a selector switch. Although the compatibility of these two formats within one projector was considered to be a difficult feat to accomplish when Super 8mm was introduced in 1965, this feature has now become the rule rather than the exception. Steady improvements in the mechanical switching procedure from one format to the other have now resulted in dual function 8mm projectors which offer the collector a reasonable degree of versatility. He can acquire those Super 8mm films he wants, taking advantage of the slightly larger screen image, as well as buying and using those films available only in the older format.

But should you seriously consider a used projector of older design, remember that they can be bought at very reasonable prices, and an ample supply of replacement parts still exists in repair shops around the country, assuring owners of most models that service can be obtained should troubles develop. However, how many more years this will be true is impossible to determine. Since a projector is a major purchase which should last for many years, a reasonable price for a used projector compared with the greater expense of a comparable current model may well weigh heavily as a factor in your decision. Still possessing a life span of several thousand hours of trouble-free projection, many of these older machines can provide you with high quality projection at a low cost, allowing the purchase of several films with the savings.

If you decide to consider the purchase of a used projector, examine the machine carefully for possible weak points in its operation which might injure your films. Obviously, the acquisition of one about to suffer a complete and total "nervous breakdown" is out of the question and should be avoided—but how to tell? Consider the following guidelines:

1. Avoid projectors whose manufacturers are no longer in business, such as Ampro, Universal, Fodeco, Apollo, and so on. Although they built reliable, sturdy machines in their day, the supply of spare parts in repair shops has dwindled or even disappeared.

2. Look at the exterior finish. Is it worn? Does it show evidence of rough handling? Is the machine free of dirt, grease, and accumulated deposits in corners and crevices? The answers to these questions will tell you something about the previous owner and how he treated the projector.

3. Run the projector in a quiet corner and listen to it carefully. Does the motor have the steady sound of good health or is there a grinding or

whirring noise present? By their nature, motors on older projectors tend to be somewhat noisy, so accept this fact, but don't confuse it with symptoms of a sick motor.

4. If the projector has a rheostat control, slowly run it up and down the scale a few times and listen to the acceleration and deceleration of the motor. It should be a steady sound with no hesitation or flat spots.

5. Engage the clutch or single frame control several times to make certain that the heat screen drops into place smoothly and that the clutch does not slip, allowing the machine to continue to run, one frame at a time. When disengaged, the screen should immediately swing out of the light path.

6. Operate the sprocket guides. They should function smoothly. Occasionally, the actuating spring of the guide has broken or worn to the point where it can no longer properly track the film around the sprocket, which causes a loss of the film loop and presents a real hazard to the safety of your films.

7. Examine the film gate and aperture plate for nicks, scratches, or gouges on the finish, which will scratch your films. If necessary, use the projector lens as a magnifying glass in your inspection.

8. Examine the optical path, beginning with the reflector behind the projection lamp. Is it clean, with a brilliant reflecting surface, or are there blisters, stains, or speckles which reduce its efficiency? Can the lamp be replaced and updated with the Sylvania adapter and a bulb of newer design? Are the condensers and heat-absorbing filter free from cracks, chips, or blemishes? Look through the lens and check for scratches. Turn on the motor and lamp switches and check for an even distribution of light on a nearby wall or screen.

9. Placing a full reel of film on both the supply and take-up arms, turn on the projector motor and observe the revolution of the reels. Do they turn smoothly, or is there an occasional hesitant jerk as they revolve? If the arms use spring belts, check their condition and tension, noticing especially the degree of difficulty or ease in replacing them.

10. Thread a film, making certain to form the loops properly, and operate the projector to check the intermittent action. Does the picture hold steady on the wall or screen, or does it vibrate up and down slightly? Notice the sharpness of the picture, both at the edge and center of the frame, and turn the lens in and out of focus to see if the barrel moves smoothly in its mount. Rewind the film to make certain the rewind mode functions properly.

Follow these ten guidelines and you will be able to locate those defects which make a used projector unacceptable to a collector. If any appear in the course of your examination, do not buy the machine unless the dealer agrees to correct whatever you find to be wrong, at a cost which seems reasonable to you. If the projector is priced above $75, the dealer should see that the defect is corrected at no charge to you. If he will not do so or if his price is exorbitant, look elsewhere.

What to pay? This is a hard question to answer, since it depends a great deal upon the condition as well as the make and model of the projector. You can check current issues of national photographic magazines to see what the large New York dealers are charging for the particular projector you have in mind, or you can ask the dealer to show you his bluebook, which lists the price range for a used projector by model. Consider the dealer's price in relation to the listed price and then determine whether you consider the machine to be in average or above or below average condition. You should be able to determine a fair price at this point, but before you lay your cash on the counter, make certain that the dealer will guarantee its operation for at least 30 days from the purchase date. If he refuses or claims that it is not the policy of the store to give a written guarantee, look at what his competition has to offer. In most cases, you will have no problem obtaining a guarantee, unless the dealer suspects or knows that the projector is about to experience major difficulties. Exercise caution, just as you would with a used car dealer, and spend sufficient time before you purchase a used projector to give it a thorough going-over—it will prove to have been time well spent when you find the right projector.

TWO PROJECTORS

Two projectors? Why not? Theaters use a minimum of two machines to effect a smooth transition between reels, and you can do the same. Turning on the lights in the middle of a two-reel comedy often breaks the continuity, a problem not encountered if you combine both reels on a larger one or use two projectors; but what about features? Interrupting *The Birth of a Nation* a minimum of five times to change reels can cause even the most dedicated cinephile to lose some interest. With a little ingenuity and a second projector, you can overcome this handicap and enjoy truly professional projection in your own home.

Both projectors should be of the same make and model, for the obvious reasons of identical film paths, optical systems, light output, the need

for only one spare bulb, and so on. In order to make smooth transitions between reels, or *change-overs,* as the professionals call them, follow these steps:

1. Use opaque leaders and trailers of sufficient length on each reel.

2. With a permanent ink nylon-tip pen, mark each reel with a dot of ink in the upper corner of three consecutive frames 24 inches from the final picture (48 inches on 16mm film) and three more dots on the fourth, fifth, and sixth frame just before the trailer.

3. Place a large "X" on the leader of each reel 24 inches before the first title frame appears on-screen (48 inches on 16mm film).

4. Designate one projector the No. 1 machine; the other will be the No. 2 projector. Thread the No. 1 machine as usual; thread the No. 2 projector with the large "X" on the leader centered in the film gate.

5. Project the first reel and as it nears the end watch the screen carefully. You will have no trouble noticing the brief flash as your first three dots pass by. This is your cue.

6. At this point, you have ten seconds to effect the change-over. Start the No. 2 projector, still watching the screen. When you see the second set of dots flash by, stop the No. 1 machine—the picture from projector No. 2 will replace it on the screen. For some collectors, counting from one to ten will help in locating the second set of dots.

7. Thread the next reel on the No. 1 machine, centering the large "X" on its leader in the film gate as before. Repeat steps 5 and 6.

With a little practice to gain confidence in this procedure, you will have a professional performance. If you should fumble a bit shutting off the projector when the film has ended, don't worry—one purpose of the opaque leader is to hold the light back from the screen. But if your placement of the dots is incorrect or you miss seeing the first set or are slow in turning on the second projector, you will experience a momentary blank spot on the screen—sharpen your timing.

You can hardly miss with this system, but some collectors who can leave their equipment set up permanently go one step further: designing a mechanical system which blocks the light from one machine and allows the other to reach the screen. Because of the numerous variations in projector styling and equipment positioning, such change-over devices can take any number of forms. Should you decide to add the mechanical system to the use of the one outlined above, I'll leave it to you to exercise your imagination with your own particular projectors and design your own.

RELATED EQUIPMENT

Whereas a projector is the first and most important piece of equipment required by the collector, there are certain other items for which he will soon discover a need. The decision to acquire a screen, splicer, editor, and rewinds must be made soon after beginning a collection becomes a firm commitment with the purchase of the projector. The great variety of this equipment, coupled with the pep talks of over-eager salesmen, often serves only to confuse the new collector further. But a little knowledge can do wonders for self-confidence (and the wallet)—so read on!

SCREENS

Indicating to a salesman that you are in the market for a projector virtually assures him that he can sell you a screen so he will work hard to provide you with "exactly the one you need." But do you really need one? The answer to this question is a qualified "yes." However, at least three situations exist in which a screen can be unnecessary and even a luxury.

1. If you are operating on a limited budget and your home or apartment has a smooth, light-colored wall with a 3 x 5 foot space (uncluttered by pictures or other decorations), you can defer the purchase of a screen if you wish. Such a surface will satisfactorily substitute as a screen for home viewing.

2. Other collectors prefer to purchase a sheet of thin cardboard (often called *railroad board*) at a stationery store or printing shop. Inexpensively replaced when soiled, this can be hung on the wall when in use and stored at other times. Should you desire to use a large sheet (over 2 x 3 feet in size), it is well to mount it on corrugated cardboard with rubber cement to provide a strengthening effect.

3. Depending upon the room arrangement, it is possible to purchase an inexpensive pull-down curtain shade which is colored on one side and white on the other. The white side can be used for projection, giving a satisfactory surface for pictures up to about 30 inches in width.

But let's suppose that you have decided to invest in a commercial screen surface, designed especially for picture projection. Will you want a wall or a tripod mount? A beaded, lenticular, or matte, or Sunscreen surface? And in what size?

Mounts

Most screens in use today are attached to a roller and enclosed in a tubular case. When in use, the screen is pulled out of the case to the desired length (the width is predetermined by the size you buy) and attached to a support rod above the case for projection. When you are finished, it detaches from the rod and rolls back up inside the case. The tubular case can be bought on a tripod arrangement, which provides maximum portability in use, or with a wall or ceiling mount which allows you to attach it permanently on a small set of brackets. Expensive wall mount screens can be obtained which will electrically lower and raise themselves at the push of a button, providing the maximum in convenience.

Fig. 5-7. Tripod screens such as this Da-Lite Challenger are convenient for many collectors; after use, the screen surface rolls back into the case and the legs fold up to form a compact unit for storage. The scene illustrated is from Charlie Murray's 1915 Keystone Comedy **The Plumber.**

Surface

More important than the mount is the surface of the screen and the fabric of which it is made. Screen surfaces are of four types—beaded, lenticular, matte, and Sunscreen.

Beaded

Probably the most popular screen surface today, the beaded screen consists of a vinyl cloth material coated with grains (beads) of silica, bonded together to form a light-responsive surface. It is fungus and flame resistant and the better grades are washable, but woe to the collector who tries to clean the less expensive variety. These cheaper screens have fewer and coarser grains, and since the bonding adhesive

has a tendency to darken with age, it creates a "salt and pepper" effect which interferes with viewing. Cleaning the surface tends to remove the beads rather easily.

TABLE 5-2

Standard 8mm

Lens Focal Length	Screen Width					
	30″	40″	50″	60″	70″	84″
3/4″	11′	14′	18′	22′	25′	31′
1″	15′	19′	24′	29′	34′	41′
1½″	22′	29′	36′	44′	53′	61′

Projection Distance

Super 8mm

Lens Focal Length	Screen Width					
	30″	40″	50″	60″	70″	84″
3/4″	9′	12′	15′	18′	21′	25′
1″	12′	16′	20′	24′	28′	33′
1½″	18′	24′	30′	36′	42′	50′

Projection Distance

16mm

Lens Focal Length	Screen Width					
	30″	40″	50″	60″	70″	84″
5/8″	4′	5½′	7′	8¼′	9½′	11½′
1″	6½′	9′	11′	13′	15½′	18½′
1½″	10′	13′	16½′	19½′	23′	27½′
2″	13′	17½′	22′	26′	30½′	37′

Projection Distance

Although the beaded screen reflects a very bright image to those viewers seated directly in front of it, the light falls off rapidly as you move from the center to the side of the room. Picture focus is sharp but not as sharp as with a matte screen because the grains form a somewhat rough surface of reflecting material. For maximum effectiveness with a beaded screen, the room should be as completely darkened as possible.

Lenticular

Almost mirror-like in their brilliance, lenticular screens combine a vertical and horizontal embossing on a silver coated vinyl surface. They produce bright pictures over a wider viewing area than beaded screens and can be used in partially lighted rooms. The lenticular screen lives up to its claim to be washable but requires a tension support rod to hold it perfectly flat and is usually more expensive than other screen surfaces.

Matte

The matte, or flat white surface, is coming back into vogue. Theater screens have had this surface for decades, because the matte screen offers the sharpest picture available. Easily cleaned with a damp cloth, it provides a relatively good picture regardless of where the viewer is located. The development of the beaded and lenticular screens for amateur movie makers caused the matte screen to decline in popularity, but screen manufacturers are again offering this type, now with a lightly textured surface to achieve a sharply defined picture over an extremely wide angle of viewing. Like the beaded screen, a matte surface requires a darkened room for best performance.

Sunscreen

Eastman Kodak has just marketed an entirely new concept in viewing surfaces. Known as the Ektalite, or Sunscreen, its aluminum foil surface is mounted in a bowl shaped styrofoam housing to control the ambient light, and it uses a fabric-like pattern to control its optical characteristics. This ingeniously designed screen is most useful under adverse lighting conditions, since it presents a brilliant picture under normal room illumination. Unlike traditional screen surfaces, the Ektalite has a friction-loaded wire bracket on its back from which the screen is hung (from the wall, the ceiling, or an easel). For best viewing results, place the lower edge of the screen slightly above the audience's eye-level and the entire screen tilted slightly downward. At present, it is expensive ($65) and

limited to only one size, 40 x 40 inches, but the Sunscreen appears to be the screen of tomorrow, and its extremely efficient surface can be useful to the collector whose films vary a great deal in quality and who screens his collection for others under less than perfect conditions. As a matter of fact, it is the ideal surface (presently) for anyone who wishes to maximize his projection enjoyment, but the cost must be weighed against its utility for the individual collector.

Before You Buy

Before you invest in a screen, it will be well to consider this purchase in terms of the information in Table 5-2 and the following questions:

1. Do I actually want and/or need a screen?
2. Can I darken the room sufficiently to use a beaded or matte surface, or will I need a lenticular one?
3. What price can I afford? Generally speaking, the inexpensive screen will be of the beaded type.
4. Will I want the screen mounted permanently, or must it be set up and taken down each time I want to use it?
5. How many people will be watching it, and where will they be seated?
6. What size screen will I need? Some surfaces may not come in the size you want.*

SPLICERS

Splicing, or the permanent joining of two pieces of film, is a task which will confront every collector. The splicer is a necessary tool which should be acquired as soon as possible for the following reasons:

1. It is often desirable to join short films on one larger reel (two-reel comedies lose something when you stop to change the reels), reducing the storage space needed for your collection.
2. You may purchase a film containing a scene that is repeated, a sign of careless lab work in preparing the printing negative. For the

*The Society of Motion Picture and Television Engineers uses a "2 and 6" rule to select screen sizes: 2 × the screen width should equal the distance from the screen to the first row of seats: 6 × the screen width should equal the distance from the screen to the last row of seats. This rule fits the screen to the audience—not to the projector—and although seldom practical for home use, it should be kept in mind if any kind of public exhibition is anticipated.

sake of the continuity of the film, this second sequence should be removed.

3. To protect the film against damage, you will want to splice on a leader and a trailer—opaque film stock at the beginning and the end of the film—to absorb any damage caused by misthreading the projector.

4. Regardless of how careful you are with your films, sooner or later one will break or tear.

Amateurs often attempt to make a splice with cellophane or masking tape. This will invariably cause further damage to the film when it is projected again—no such temporary bond will work properly. The correct use of a film splicer becomes an absolute necessity to the collector.

Splicers come in almost every shape, size, variety, and price. In such a competitive market, you can expect to find a wide range of quality. Before shopping for one, be certain that you know exactly what you want and take the time to consider your needs carefully before you make a purchase. If in doubt about the type or make of splicer you want, visit a camera store and ask for a demonstration and/or explanation. Don't simply take the clerk's word that his favorite splicer is just what you want or need since he may be trying to sell a high commission item to help move the stock in the store.

Splicing Methods

Until a few years ago, all splices were made with cement and a splicing block, but now you have a choice between the cement variety and Mylar tapes. These two systems are commonly referred to as *wet* (cement) and *dry* (tape) splices. The dry, or tape, splice, which has caught

Fig. 5-8. A simple splicing block will suffice for emergency repairs and can be carried in your pocket.

on for a number of reasons, possesses several distinct advantages over the older wet, or cement, method. It is possible to buy a combination splicer designed to be used with either method, a good compromise for the beginner who finds it difficult to choose between systems at the outset.

Cement Splicing

Generally speaking, the outstanding characteristic of the cement splice is an overlapping of the film ends to effect the splice; when projected, this overlap shows on the screen briefly and distracts the eye. If the cement is to weld the film ends together permanently, the emulsion, or dull side, of the film must be scraped clean, allowing the solvent action of the cement to act upon the film base. Unless all of the emulsion is removed, this action will not take place properly, resulting in a faulty splice. The major reason for film failures is poor splicing; the major cause of poor splicing is improper preparation of the film.

Tape Splicing

Although the cement splicing technique has only its low cost to recommend it to the collector, the tape splice has a number of clear advantages which include the following:

1. A torn film or one with broken sprocket holes can be repaired without having to destroy or remove any of the damaged sections.

2. The splice does not show on the screen because the cut is made exactly on the frame line between pictures, and the splicing tape is made of optically clear Mylar with a pressure-sensitive adhesive which adheres to all types of film base—nitrate, acetate, triacetate, and the newer polyesters. (Caution: some of the dry splicing systems lack this advantage because they make a notched or S joint instead of a frame-line cut.)

3. Frames adjoining the splice are not spoiled by cutting or overlapping, a feature of particular interest in a short scene.

4. The film plane remains constantly in focus throughout the spliced area. No bump on the screen due to the overlap occurs as the splice passes through the film gate.

5. Tape splices can be removed if necessary without damage to the film but will not shrink, dry out, or become brittle with age.

6. If a magnetic sound track is to be added to the film, the splice will not pop, hiss, or squeal when projected.

7. Tape splicing does away with the major reason for film failure—im-

Fig. 5-9. Splicers are available in a large variety of shapes, sizes, and purposes—(a) the Craig All-in-One Master Six Splicer S-6 will make either cement or tape splices on Standard 8mm, Super 8mm, and 16mm film; (b) the Griswold R-2 is a longtime favorite for cement splices; (c) Agfa makes many models for cement splicing; (d) the H.P.I. Quik Splice for tape splicing comes in a variety of models; (e) the Du Page Splic-A-Matic 616 uses a special roll of tape to cover both sides of a splice at one time.

a.

b.

c.

d.

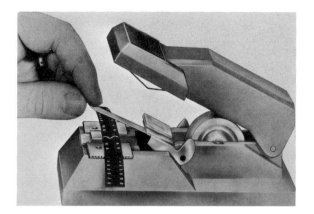

e.

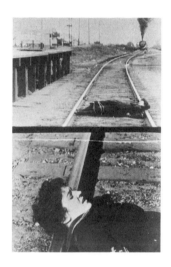

Fig. 5-10. Actual frame enlargements from a Helen Holmes serial illustrate the popular old cliché of the girl awaiting certain death. Notice the white splice line in the bottom frame above her head. As it passes through the projector, this cement splice will "bump," causing the eye to notice its presence and temporarily upsetting the focus on the screen.

Fig. 5-11. Some of the advantages of tape splicing.

FILM CUT
EXACTLY ON
FRAME LINE

FILM
INVISIBLY
BUTT SPLICED

BROKEN
SPROCKET HOLES
REPLACED WITHOUT
LOSS OF FRAMES

TORN FILM
REPAIRED WITHOUT
LOSS OF FRAMES

99

proper scraping of the emulsion—and is neat, clean, and quick, with no chance of spilling messy fluid.

As you might expect, with all of these advantages in their favor, tape splices cost considerably more to make than their cement counterparts. Whereas a 65¢ bottle of splicing fluid will make many hundreds of splices (if you don't forget to tighten the cap on the bottle when you are finished with it), the Mylar tape splices cost between 1¢ and 3¢ each, depending upon the quantity and brand you purchase.

Techniques of Splicing

Proper splicing techniques are important. You will need to splice leaders and trailers to your films, or you may wish to connect two or more reels of film on a larger reel. Regardless of how carefully you handle it, a film will occasionally break, if for no other reason than to satisfy the law of averages. Here are step by step instructions to help you make long-lasting splices using either the cement or tape methods.

Cement Splicing

1. Place the film, emulsion side up, in the righthand bed with the end of the film overlapping the cutting edge, and then close the clamp. Lower the lefthand bed to cut off the excess film. (See Fig. 5-12a.)

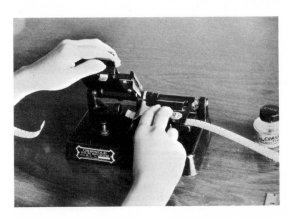

Fig. 5-12a.

2. Lift the righthand bed and clamp. Place the other piece of the film to be spliced in the lefthand bed (emulsion up), overlapping the cutting edge, and then close the clamp. Lower the righthand bed to cut off the excess film and lift it back up. (See Fig. 5-12b.)

100

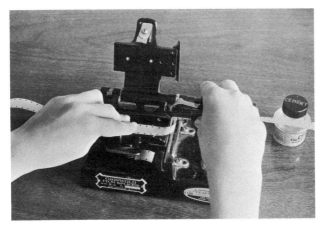

Fig. 5-12b.

3. Carefully remove the emulsion by scraping the film. This can be done with water and a razor blade (a drop of water applied to the emulsion softens it for scraping), the end of an emery board, or the built-in scraper blade that comes with many splicers. If the emulsion cannot be removed to give the appearance described in step 4, you probably have the film in the splicer incorrectly. Check carefully to make certain that the *dull* side faces you (see Fig. 5-12c).

Fig. 5-12c.

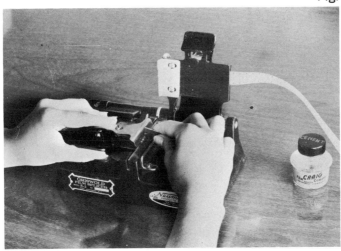

4. After scraping, check to make certain that all of the emulsion has been removed from the film. If properly done, the area to be spliced will have a frosted appearance like that of groundglass. Apply the cement with the brush which is attached to the cement bottle cap (see Fig. 5-12d).

5. Close the righthand bed quickly and replace the brush in the cement bottle. Wait approximately 10 seconds (see Fig. 5-12e).

6. Open both clamps and remove the spliced film. If you wish, test it for strength. Leave a little slack near the splice, and then gently snap the film by moving your hands back and forth. If the splice has been properly made, it will hold; if not, it will come apart at this time and the procedure should be repeated after you have determined what you did incorrectly. The mistake is usually failure to remove all of the emulsion properly (see Fig. 5-12f).

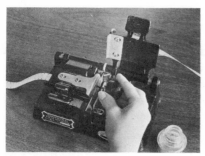

Fig. 5-12d.

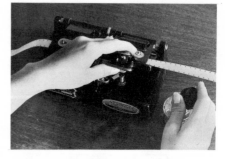

Fig. 5-12e.

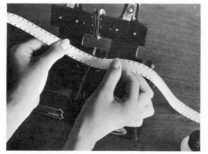

Fig. 5-12f.

102

Tape Splicing

The technique of dry splicing is quite simple, and although you may think that you are all thumbs the first few times, it can easily be mastered with a bit of practice.

1. Raise the lefthand cutting blade and place the film end on the righthand side, securing the film over the alignment pins. Because no solvent welding action takes place and both sides of the tape will be used, it is not necessary to be concerned about the emulsion side. Lower the lefthand blade to trim the end if necessary (see Fig. 5-13a).

2. Raise the righthand blade and place the other film end on the lefthand side, again securing the film over the alignment pins. Lower the righthand blade to trim the excess if any (see Fig. 5-13b).

3. Place the precut Mylar tape splice over the film, aligning it on the pins over the film. Then remove the paper backing and press the splice securely onto the film (see Fig. 15-13c).

Fig. 5-13a.

Fig. 5-13b.

Fig. 5-13c.

4a. If the Mylar splice is of the double variety, carefully remove the film from the pins, turn over, and realign, folding the splice over as the other paper backing is removed. This is done only in the case of 8mm; 16mm dry splicing requires following step 4b. (See Fig. 5-13d.)

4b. If the splicing tape is not one of the double kind (8mm) or if you are splicing 16mm film, carefully remove the film from the alignment pins, turn over, and realign. Repeat step 3, using another tape splice so that both sides of the film are covered with the Mylar tape.

5. Remove the spliced film from the pins and rub the splice briskly on both sides to assure complete adhesion of the tape to the film (see Fig. 5-13e).

Fig. 5-13d.

Fig. 5-13e.

FILM EDITORS

Whereas a splicer is a necessity, a film editor can be considered a luxury, but no serious collector should overlook the great help and convenience inherent in this piece of equipment. Taking its name from its use in assembling, or "editing," motion picture film, the editor is really nothing more exotic than a simplified projection system using a prism shutter, a condenser and projection lens, one or more sprockets, a series of idlers or guides, and a small built-in screen on which the picture is projected. Although a few motorized editors are now being marketed within the price range of the average collector, the majority are powered by hand, using a pair of rewinds to hold the film reels. Rewinds can be separate but the trend is to attach them to the editor in the form of folding arms, providing a lightweight, compact unit. A few editors even have their own built-in splicers.

The film editor serves two distinct and useful purposes for collectors of classic films.

1. It can be used to preview a film or to quickly locate a particular scene without having to set up a projector and darken the room.

2. It is a very handy maintenance tool when removing double sequences, flops, a slipped frame line caused by an incorrect splice, and other defects.

If you are working with 8mm film, using an editor takes on an additional value. The 8mm picture area is so small that it is virtually impossible to work accurately and quickly using only the naked eye. Under certain conditions, even working with 16mm films can be frustrating without the assistance of an editor.

As with splicers, manufacturers offer a great variety of editors—some very good but many unsuitable for the collector's needs. In 8mm the trend is toward the dual purpose editor which will handle either Standard or Super 8mm film by replacing the sprocket and aperture mask, either by hand or by the turn of a knob. Good single purpose 8mm editors are still marketed in spite of the great boom in Super 8mm among home movie fans, and unless you have or anticipate a definite need for the dual function editor, a single purpose one will probably prove more satisfactory (no lost or mislaid parts preventing the use of a particular format) at a slightly lower cost. The 8mm editors range in price from $12 and up, depending upon the quality, construction, and features desired. The variety is quite limited in 16mm, as well as rather expensive, so plan on spending at least $65 for one in this gauge. No 8mm—16mm dual function editors are presently made. You might do well to look for a used 16mm editor. If one can be located, it will reduce your cost about 40 per cent. For the collector who uses both film sizes, two separate editors will be needed, making the total investment quite expensive. If funds are limited, purchase the 8mm editor first.

Before investing in a film editor, look over the available models as carefully as you did when buying your splicer. Visit a reputable camera shop with one of your films and ask a clerk to demonstrate the various models which appear to satisfy your needs. In evaluating them, remember that there is no used market in 8mm film editors and should you decide to upgrade your equipment at a later date, your chances of disposing of an 8mm model are slight. Consider the purchase of an editor in the same category as your projector—a capital investment which will serve your needs for many years. Don't skimp unnecessarily on cost.

Fig. 5-14. Editors also come in many models—some alone, others in combination with splicers and rewinds. Make a careful evaluation to determine the one best suited to your needs. (a) The Craig 16mm Model V 1643; (b) the Craig Projecto-Editor (available in either 8mm or 16mm); (c) the Craig Projecto-Editor (available without rewinds or splicer); (d) the Vernon Dual 8mm Editor; (e) the Baia Dual 8mm Ultraviewer; (f) the Baia Instaview 270-Dual 8, with motor-driven rewinds.

a.

b.

c.

d.

e.

f.

Before You Buy

To help you decide exactly which of the many editors will be most practical, consider the following features you should look for:

Weight: An editor should be heavy enough to stay in one place while in use. Some of the less expensive 8mm editors with built-in rewinds are so lightweight that you have to chase them all over the table.

Portability: If you have to store your equipment when not working with it, one of the units with folding rewinds might be most appropriate. If at all possible, acquire an old table to serve as an editing bench. The editor and rewinds can then be permanently mounted and ready for use at all times.

Construction: Although plastic has become a very popular material, leading to a proliferation of inexpensive editors on the market, metal castings remain the standard by which the collector should make his final choice. Metal lends the desired weight as well as providing a sound support for the swing out, locking type of rewind.

Features: Depending upon the cost and manufacturer, editors come with a variety of features. For the collector's use, the following are a must:

1. Screen size—Screen size should be at least 3 x 4 inches, providing a large enough picture for viewing without eyestrain. The screen should be well shaded from extraneous external light.

2. Adequate illumination—Since editors vary a great deal in the efficiency of their optical systems, it is not possible to specify a desirable minimum bulb wattage. Look for a system which contains a Fresnel-type field lens behind the screen. This will give a uniform corner-to-corner illumination, eliminating the "hot spot" often found in poorly designed editors, which fades rapidly to darkness near the edge of the screen.

3. Film path—This should be of a simplified design and of precision machined metal. Plastic aperture gates, sprockets, and idlers tend to scratch your films and should be avoided in an editor just as in a projector.

4. Focus adjustment—Since film stock varies in thickness, depending upon the type and manufacturer, the editor should have a focusing option.

5. Frame adjustment—The framer will allow you to make the small adjustments necessary to keep the picture properly centered on the screen.

6. Frame punch—This allows you to physically indicate on the film

edge where a cut should be made to remove a bad frame or a double sequence. Without the punch, you are likely to lose your place while removing the film from the editor.

7. On-off switch—Pulling out and replacing the cord can be a tedious interruption if it is the only way to turn off the lamp which heats up the convection-cooled editor quickly. The switch should be located on the body of the editor itself, but if not, one on the line cord will do. If the editor you choose does not have a switch at all, have one installed on the cord. Some of the more expensive models have a switch that turns on the light when the film is locked into the film gate—opening the gate automatically shuts off the light.

When you have narrowed the field down to two or three possibilities, ask the salesman to remove the top so that you can check the internal construction. It should be neatly laid out, with easy access to the bulb for replacement. If it is gear driven by the sprocket and the gears are of machined brass, you have selected a quality editor with a potential for a long and trouble-free life.

REWINDS

Although the majority of new editors contain rewinds built-in as integral parts of the unit, many collectors prefer separate ones which can be used simply to rewind, clean, and lubricate, or to hold the film while splices are made which do not require the use of an editor. Separate rewinds will have to be permanently mounted either on an editing bench or on a length of board cut to fit, and they should have a capacity sufficient to hold the largest reel you anticipate using. Whereas 8mm rewinds are limited to a 400-foot capacity, 16mm rewinds can be obtained to handle up to 2,000 feet, and it is even possible to purchase rewinds which will accept both 8mm and 16mm reels, a thought to bear in mind if you collect or plan to collect in both sizes.

An inexpensive pair (usually including those which come attached to the editor) will consist of one dummy and one geared rewind, but it is most convenient to purchase a matched pair of the geared kind. Rewinding in either direction will be fast and efficient, as the gear ratio increases the number of revolutions a reel makes for each revolution of the rewind handle. Dummy, or non-geared rewinds, operate at a 1:1 ratio, or one revolution of the reel for each turn of the handle; geared rewinds having a 3:1 or 4:1 ratio are most desirable, especially if large reels are to be used.

Fig. 5-15. Rewinds can be bought alone and mounted by the collector in accordance with his own individual editing situation. (a) The heavy duty Craig "Pro" rewind accommodates both 8mm and 16mm; (b) the Craig R-18 Junior rewinds take a 400-foot reel of Super 8mm only; whereas (c) the Kodak Showtime rewinds are restricted to Standard 8mm.

a. b.

c.

CHAPTER VI

CARE, REPAIR, AND STORAGE

Once you have acquired a projector, its proper care will reduce immeasurably the amount of repairs which your films will require. Provided you keep your projector in good working order and use it properly, your films will only need a periodic cleaning and proper storage to insure a long life, as most film repairs are the result of either faulty equipment or improper use.

EQUIPMENT MAINTENANCE AND FILM USE

Keep the projector clean and in proper working condition! When film is transported through the projector, small pieces of lint, dust, and dirt combine with projector oil to form a debris which gradually accumulates

Fig. 6-1. Never allow the film gate of your projector to become this dirty. Clean it with a soft brush after each reel has been shown.

111

around the sprockets and inside the film gate aperture as well as on its surface. Clean the sprockets with a stiff brush after each showing but clean the film gate and its aperture with a soft brush after each reel has been shown. This helps to prevent the build-up of debris, one of the major causes of scratched film.

Keep the projector lens (and condensers, if your projector has them) clean by periodically removing dust with a camel's hair brush. A spot or two of silicone eyeglass cleaner and a soft cloth should be used when the lens is really dirty.

Although all of the newer projectors have lifetime lubricated bearings, gears, and so on, older projectors do require periodic oiling. If your machine has small oil cups for this purpose, lubricate them with sewing machine oil after every 10 hours of use.

Use only the replacement projection lamps specified by the manufacturer. Don't attempt to put more light on the screen by increasing the recommended wattage of the lamp. The blower system which circulates cool air around the film gate will not be able to compensate for the increase in temperature, and excessive heat can damage your films.

Operate the projector correctly! When using the projector, make certain that all switches are in the proper mode before threading the film. Don't expect the film to run forward if the projector take-up mechanism is set to rewind. Careful checking before starting the projector in motion will prevent a torn or broken film.

Although some projectors allow you to change gears from forward to reverse and back without first stopping the machine, don't do it. If you wish to change the direction in which the film is traveling, do so only after stopping the projector. This avoids the stress which a sudden change in direction puts on a moving film—stress which can result in a snapped splice or a badly torn film.

Thread the projector correctly! When threading a film, make certain that the projector sprocket teeth actually engage the sprocket holes of the film properly. Careful threading will avoid the possibilities of ruining the sprocket holes.

It is also a wise practice to attach at least 36 inches of opaque film to the beginning (called a *leader*) and end (called a *trailer*) of each film. Using a leader and trailer serves the following four purposes:

1. It absorbs any undue stress and strain which starting and stopping the projector may place on the film.

2. It protects the actual film from damage due to incorrect threading by the projectionist.

3. It avoids the possibility of damage to the last scene which sometimes occurs during rewinding.

4. It can be purchased in a variety of vivid colors and used to color-code the type of film, differentiate the beginning from the end, and provide other forms of identification which you might desire.

Secure the film reels properly! Make certain that the full reel of film and its corresponding empty take-up reel are both securely attached to the reel spindles. It is embarrassing to chase an unwinding reel of film across the floor in the dark and difficult to replace the footage stepped on by those who leave their seats to help you recover the reel. Discard badly bent reels. These will scuff the edge of the film when used.

Rewind the films carefully! Whether the film is rewound by the projector or a pair of hand rewinds, be certain that the film is not rewound too tightly. Never pull the film to take up slack on the reel—this will "cinch" the film and cause noticeable scratches.

Consult your instruction booklet! Manufacturers furnish instruction booklets with their equipment solely as an aid to its new owner. Take the time to become fully acquainted with all of the features of your projector and the recommendations for their use. Although it is beyond the scope of this book to specify instructions for the use of every particular make or model of projector, a general guide to correct operation of any motion picture projector is listed below for your reference.

GENERAL DIRECTIONS COMMON TO OPERATING ALL MOTION PICTURE PROJECTORS

Set Up

1. Place the projector on a sturdy, level surface. Remove the cover or case to expose the operating controls.

2. Plug the power cord into the outlet, connecting to machine if necessary.

3. Position reel arms, if necessary.

Adjust

1. Turn on the motor and lamp switches.

2. Rotate the lens barrel in and out until the aperture image is sharply defined on the screen.

3. Clean the aperture with a soft brush.

4. Turn off the motor and lamp switches.

Thread

1. Place an empty reel on the take-up spindle.
2. Place the reel of film to be projected on the feed spindle.
3. Film should unwind from the reel in a clockwise direction with the sprocket holes on the side facing the operator (16mm silent film has sprocket holes on both sides).
4. Position the film over the upper sprocket and clamp into place.
5. Open the film gate, insert the film into the film channel, and close the gate, making certain to form a loop between the sprocket and the film gate.
6. Form another loop and position the film over the lower sprocket, clamping it into place.
7. Connect the film to the take-up reel and wind up the slack.
8. Test the threading with the hand test knob, if projector has one.

Operate

1. Turn on the motor and lamp switches.
2. Center and frame the picture on the screen.
3. Check the film loops and take-up reel to make certain that the film is being transported properly.
4. Turn off the motor and lamp switches when the film is finished.
5. Rewind the film according to the directions for your particular projector.

FILM LUBRICATION

When distributors receive a new shipment of prints from the laboratory for sale to collectors, the prints usually contain some moisture in the emulsion. As a result, these "green" prints often refuse to run through your projector properly. As each damp frame is pulled into the projector's film gate, the moisture within the emulsion causes the frame to stick momentarily, which results in a jerky picture on-screen. Exposure to heat through the aperture is insufficient to dry out the dampness, because the frame remains there for only a fraction of a second.

By subjecting the new prints to an anti-scratch film preservative process at the laboratory before shipment, more and more distributors are helping to conquer this annoying problem in the prints they sell. The film preservatives such as Vacumate or Permafilm harden the emulsion and in so doing reduce the amount of moisture below a troublesome

level. But should you encounter a "green" print, you can "cure" the film (and the problem) by using a silicone-treated cloth (obtainable from any photographic dealer) in the following manner:

1. Place the reel of film to be lubricated on your rewinds or use the projector, operating it in the rewind mode. Choose whichever method works best for you. Some collectors prefer to control the speed at which the film is drawn through the folded cloth by using rewinds; others, who are all thumbs, find that allowing the projector to supply the motive power leaves them free to concentrate on the lubrication process itself.

Fig. 6-2. Film lubrication using the power rewind of the projector.

2. Fold the cloth over the film, covering both sides at once, and apply constant but light pressure with one hand to assure continuous contact between the film surface and the cloth. Trial and error on a practice strip of leader will indicate exactly how much pressure you should exert.

3. Draw the film slowly through the folded cloth, occasionally stopping to refold the cloth. This will apply a light silicone coating to the film. As it is a lubricating agent, the silicone prevents a new film from sticking in the aperture, allowing normal projection.

Once it is applied in sufficient quantity (especially by laboratories which apply silicone to prints before releasing them for sale), the silicone is almost impossible to remove completely, because it permeates the

emulsion and the base. Should you desire to tint your films (see Chapter VII), *do not* use silicone as a lubricating agent. Vitafilm, Kodak Movie Film Cleaner with lubricant, and other solutions are available at photo stores in sizes ranging from one-quarter pint to one-gallon containers but should be tested on a strip of film containing a splice before general use. Vitafilm in particular is not recommended for use with tape splices, as it has a tendency to loosen the adhesive of the splice; the Kodak solution is harmless to either tape or cement splices.

Some collectors prefer to treat a "green" film with a solution of Chlorothene in which ordinary beeswax has been dissolved. This can be mixed to the correct proportions by almost any film processing laboratory* and is applied with a soft lintless cloth used in the same manner as the silicone-treated cloth. Other collectors find that the temperature and humidity combination where they live introduces the factor of static electricity in combination with a "green" print. In this case, the film actually attracts and retains dirt, dust, and lint as it goes through the projector. To combat this additional and damaging nuisance, such films can be treated with a solution of V. M. & P. Naphtha, applied as above. But unless you wish to tint your films, I recommend silicone as the most permanent and effective lubricant and cleaner available.

FILM CLEANING AND PRESERVING

If your films are kept properly lubricated with silicone, cleaning will most likely be unnecessary, for the silicone tends to hold whatever dirt, grease, and lint has accumulated on the surface. When you relubricate the film with silicone, the cloth removes this surface debris at the same time. If you do not use the silicone treatment or if your films receive considerable use between lubrications, a photographic film cleaner will remove heavy concentrations of dirt more efficiently and thoroughly. Whereas carbon tetrachloride was once the only effective cleaner on the market, it has been replaced in recent years by commercial preparations and should be avoided by the collector, as the fumes are both inflammable and dangerous to breathe. Any well-known brand of film cleaner will work nicely and is applied in the same manner as the silicone. Simply change the fold of the cloth every 100 feet or so, moistening each new fold with cleaner, but be certain to relubricate the film after such cleaning.

*This preparation can be obtained commercially as Eastman Chemical number P7421 or Hercules B-16 Synthetic Wax.

Fig. 6-3. A set of mounted rewinds. The same technique is used with film cleaning fluid.

If any of your films has a magnetic sound striping, it is advisable to conduct a test on a small portion to make certain that the cleaner does not dissolve the binder in the stripe. Should a particular cleaner soften or smear the stripe on the test strip, choose another brand and test that one to determine its effect.

When to Clean and Relubricate

Since you cannot *see* the surface dirt easily, it is difficult to determine when to clean and relubricate the film. It depends to a large extent on how and where the film is stored, as well as how often it is used. Each individual collector will have to set cleaning periods at intervals according to the amount of use his collection receives, but it is a good idea to check the condition of each film at least twice yearly, cleaning and lubricating if necessary.

PROPER STORAGE

It is easy for the collector to overlook proper storage of his collection since deterioration is a slow process, but neglect of proper storage makes all of the other precautions we have considered futile. Whereas there is a wide variety of different storage arrangements, the one you choose will depend on how much of your budget you wish to expend in

117

this manner and will be dictated to some extent by where you live. Put simply, film should be stored in a container, on a shelf, and in a central location.

Since the most common enemies of film are dust and dirt, it should be stored in some sort of container. Although the simplest and least expensive method is to store your films in the boxes in which they were bought, much better (but more expensive) protection is provided by metal film cans. These cans have tight fitting covers which effectively keep out unwanted contaminants and are much more useful, especially if your films will be used a great deal; the cardboard boxes tend to wear out rather quickly.

To keep your films in a central location, a storage area of some kind will be needed. This can be as simple as a shelf or drawer set aside for this particular purpose, or you can purchase special shelving (either open or in cabinet form) designed specifically to hold films. The best protection, of course, comes from an enclosed storage area, such as the drawer or cabinet already mentioned. The major consideration is to keep your films together in a central location where their exposure to contaminants can be controlled and minimized. Film cans may be stored either upright, on edge, or flat.

Storage areas should never be located in a basement (too damp) or on the top floor of an uninsulated building (too hot). Avoid areas near steam pipes, radiators, hot air ducts, windows, and other sources of heat or humidity. In an ideal situation, films would be stored in a room supplied with filtered air at a temperature of 60° F and a relative humidity of 40 per cent, but few collectors can afford to construct their own private film storage vault to assure such control. Fortunately, black-and-white films printed on a safety film base can withstand temperatures up to 80° F and a relative humidity range of 25 to 60 per cent. For the most part, the storage of such films presents no special problems in those parts of the world having moderate climatic conditions, but even so, it is wise to spot check your collection frequently for signs of trouble.

Humidity Too High

Storage in high relative humidity for any length of time results in mold or fungus, shiny marks on the emulsion surface, and rust or corrosion on the metal reels and cans. Mold or fungus growth can be removed by cleaning the film, but these signs constitute a signal that the relative humidity must be reduced. If humidity control is not possible, a small

packet of silica gel can be enclosed with the film reel in its storage container. Remove the packet periodically and place it in an oven set at 350° F for 10 minutes. This removes the accumulated moisture—return it to the film can when cool and the silica gel is ready to absorb more moisture.

Humidity Too Low

Humidity levels below 25 per cent will eventually result in dry, brittle, and curly film, easily damaged by handling or projection. In such cases, remove the film reels from their containers, standing them on edge to permit free circulation of air around them. Place several containers of water in the room to increase the relative humidity in the air.

Magnetic Sound Stripes

Films with a magnetic sound stripe require the same care as those without it, but remember not to store them near a permanent magnet or close to electrical wiring which carries a heavy current. Such exposure will demagnetize the magnetic stripe, erasing the sound track. Heat and humidity will cause the magnetic stripe to deteriorate along with the film —an important point to keep in mind, especially if the sound stripe is of the laminated variety. Under adverse storage conditions, this type of stripe will physically separate from the film to which it has been applied.

Proper attention to cleaning, lubricating, repairing, and storing your film collection will assure virtually a lifetime of trouble-free enjoyment. Safety film and magnetic stripes have not been in existence for centuries as has paper, but to the best of our scientific knowledge, based on exhaustive laboratory tests, there is no reason to believe that either will fail to stand the test of time. All that is required is a little effort on your part.

FILING SYSTEMS

As your collection begins to grow, a filing system will become a necessity. You will want to locate different films without sorting through reel after reel looking for a particular one. You will also need to identify the contents of a film container without unreeling the footage all over the floor, looking for a title or checking to see if the film is ready for screening or needs to be rewound. Decide upon a suitable system at the outset and use it as each new film is added. A variety of materials can be used to create different identification systems; pick the ones to suit your own needs.

Identifying

Film containers: Use a permanent ink felt or nylon pen to write the title, reel number, file number, and other information on the can or use a tape labelmaker to punch out the desired information, peeling off the backing of the tape and sticking it to the container. (Tape labelmakers are much used for this purpose by collectors, but expect the adhesive to dry out over a period of time and the label to fall off unexpectedly.)

a. b.

Fig. 6-4. Film cans can be identified in a variety of ways. Shown here are the use of: (a) a permanent ink felt pen and (b) a tape label-maker.

A film separated from its container: Use a permanent ink felt or nylon pen to write the title, reel number, file number, and other information directly on the leader.

Type of film: Use a colored leader stock to indicate type (red for comedy, blue for serials, green for features, and so on) and gray trailer stock or use different color reels for each type, but be certain to rewind films back on the correct reels.

Film ready to show: Use one color opaque film stock for the leader and a different color for the trailer or write "head" on the leader and "tail," or "end," on the trailer with a permanent ink felt or nylon pen.

After your collection has reached a certain size, you will find it quite

difficult to remember exactly what you have and where to find it quickly. A 3 x 5 file card system in which each film is assigned a particular file number will be helpful, allowing you to collect miscellaneous information of interest about each film on the back of its card. This will be handy for ready reference in case of outside showings when introductory material is required to present to the audience before screening the film.

The back of the file card can also be used to keep a cleaning/lubrication record. With this information on hand, you can systematize your film maintenance, setting aside a few hours periodically to clean and lubricate only those films which are in need of it.

SHIPPING

If you should exchange films with fellow collectors by mail, be certain to pack your films (as well as theirs) carefully in rigid containers which will survive the rough handling of postal delivery. Heavy fiber board cases are sold especially for this purpose; it would be well to buy one or two. According to current postal regulations, films can be mailed at an educational rate considerably below that of regular parcel post, providing the package is plainly marked Special Fourth Class Rate—16mm and Narrower Film Gauges. Pay the small fee for Special Handling and your film shipment will usually reach its destination safe and sound long before parcel post.

CHAPTER VII

ADDING COLOR TO THE CLASSICS

Although the reproductions of classic films available to collectors today are black-and-white, many of the originals were colored! The process of full color as we understand it today was not available to silent film makers, but the earliest practice, one which developed almost concurrently with the motion picture itself, made use of hand colored frames, a laborious process which was gradually semi-automated by the introduction of stencils to the coloring process.* This technique gave way to the early attempts to make true color films, a vogue which failed to catch on with the public.

As 1912 dawned, producers started to tint their release prints chemically with aniline and sulfur dyes to heighten the dramatic effects, visually conveying certain moods to the audiences. Such dyes stained both the highlights and shadows but did not alter the underlying image color.† All scenes which represented night sequences had to be taken during daylight hours, as panchromatic films and sophisticated lighting techniques were not available to the early movie makers. But such scenes were unconvincing, especially when preceded by a title indicating that it was night, which specifically drew the audience's attention to the incongruity. The effort on the part of the audience to imagine that it was nighttime was a distraction in itself. When a blue tint was applied to the

*Some of the early hand colored films of the French pioneer Georges Méliès have been copied by one distributor and printed on color stock to preserve the full effect of this primitive technique.

 † Toning, an entirely different process, chemically changes the image color to that of the toner. Although effective, toning does not provide the strong visual impact which tinting imparts to the eye.

film, softening the often harsh highlights, a more realistic atmosphere was created in night scenes, and the change in color on the screen cued the audience to the time of day more naturally.

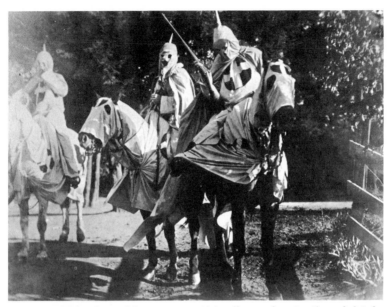

Fig. 7-1. A blue tint adds an unearthly dimension to the night forays of the Ku Klux Klan in **The Birth of a Nation.**

Fig. 7-2. Night scenes like this one from **The Jungle Goddess** are greatly enhanced by a red tint. Ordinarily, blue would be used to suggest night but in this particular case, red strengthens the emotional impact of the religious ceremony being portrayed.

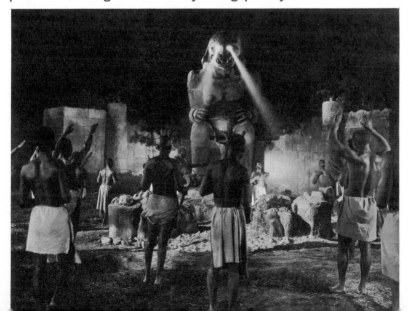

Other colors had specific meanings; red was used in western campfire scenes and fire fighting sequences—wherever fire and danger were present. Amber was used in indoor night scenes; yellow and sepia became standard tints replacing the black and white of ordinary daylight scenes. Green became associated with water scenes. Tints were varied in hue to match the emotional intensity of the sequences and sometimes combined for special effects like pinkish-yellow sunsets. The use of these tints was desirable from the standpoint of ease in viewing and artistry, but their application was a time consuming additional expense in laboratory work for the producers. Eastman Kodak solved the problem in 1924 with its introduction of a variety of nine tinted film stocks. Release prints were made just as before but, when developed, the desired tint was already there. This new film stock eliminated the additional step and the cost of tinting release prints after development, and its use led to a more pleasing and artistic rendering of the story on the screen.

Fig. 7-3. Most critics of present-day Hollywood nudity have forgotten that the silents contained their share of tastefully presented nude scenes. This one from **Dante's Inferno** is a part of a sequence depicting Hell (as pre-World War I producers imagined it) and should be selectively tinted, using a variety of colors. The resulting kaleidoscopic appearance becomes symbolic of the turmoil in Francis Ford's mind as Grace Cunard tours the lair of the Devil with her admirer.

Today film collectors cannot imagine the effect of such a film, unless they have actually seen one projected. Even the amber Kodascope prints, with a distinctive charm all their own, do not leave a viewer with the impressions which a variety of tints keyed to each film sequence can convey. Commercially tinted films passed into oblivion in the late thirties as more and more labs acquired fully automatic processing machines and full color processes became less expensive. But the collecting of classic films as a hobby has brought about a renewed interest in this aspect of authenticity. Collectors who can devote the few additional hours required to tint their own films will find that the end result is well worth the extra effort, but I suggest that you confine your initial efforts to a single reel which you do not value highly, for it is well to practice a technique for proficiency before undertaking a major project.

But one caution—think ahead! The collector who is intrigued with the possibility of adding color by the process of tinting *should not* apply silicone to his untinted films as a lubricant/cleaner. Silicone cannot be completely removed and will resist the tint. Some distributors are now applying a silicone finish to their prints before offering them for sale. To test a print before going through the following procedure only to meet with failure, clip a short length from the leader of the film as it comes from the distributor and immerse this clip in a small quantity of tint for a minute or two. If the color does not take, the print has been treated with silicone. In this case, a print without the silicone treatment can be purchased on special order, usually at a 10 per cent to 20 per cent premium, as the laboratory must pull the film out of the automatic equipment before the machine cycle is completed. If you desire to tint a particular print which you are thinking of purchasing, it is best to write the distributor and inquire as to whether the lab application of a silicone treatment is routine. If it is, place a special order; if not, you are safe with a print from stock.

TINTING CLASSIC FILMS

Tinting a film requires an editor and rewinds, a number of small reels such as those on which home movies are returned, a home movie processing rack or reel which also doubles as a drying unit, and a variety of aniline dyes, such as eosine red, methylene blue, naphthol yellow, and so forth. These can be obtained from any chemical supply house complete with directions for their use. When ordering or purchasing these dyes, be certain to specify the use to which you intend to put them—film

125

tinting requires the use of a dye which is chemically inert and will not attack the emulsion. Prepare your film in the following manner:

1. Select the film to be tinted and test for the presence of silicone. If the print passes this test, use the editor to note the beginning and end of each sequence in which a different tint is desired. A simplified example would be to have the first half of a reel tinted yellow, followed by a blue sequence which yields to red, with the remainder of the film yellow. Plotting out the tinting process on paper is necessary not only to assure that each sequence receives the correct tint but also to guide you in the proper reassembly of the film when the process is completed.

2. Clean the entire film very thoroughly with a commercial film cleaner to remove all lubrication as well as accumulated dust and dirt. This is very important since film lubricants and waxes will reject the tint. If the film is not completely free of them, the tinting will not be uniform.

3. Carefully separate each sequence to be tinted by cutting on the frame line and marking it at the beginning for identification. This can best be done with short lengths of thread the same colors as the various tints you plan to use. Tie the proper color thread around a sprocket hole at the beginning of each sequence and knot loosely. If the film presents a complicated task of reassembly, with many small sections to be cut and tinted, it may work best to loop the thread through the correct number of sprocket holes to indicate the proper reassembly sequence; one sprocket hole for sequence one, two sprocket holes for sequence two, and so on.

4. Wind each piece of film onto a separate reel as it is cut, marking the reel for the tint to be used.

5. Prepare the tint according to the accompanying directions. Adding ⅛ ounce of dye to 1½ gallons of water will usually provide the desired strength. Do not worry about the depth of color in the tint bath —the final shade depends upon the length of time the film is immersed in the dye.

6. Grouping all sequences to be tinted one particular color together, wind each onto the processing reel or rack from their individual reels and fasten securely.

7. Soak the film for 15 minutes to soften the emulsion and make it receptive to the dye. Drain and then immerse it in the dye bath for 5 to 10 minutes, inspecting it visually to check on color density.

8. Follow the dye bath with a 30-second rinse in clear water to remove the excess tint and prevent streaking. Before drying, spin the processing reel several times to remove as much water as possible.

9. Allow the film to dry in a dust-free area for 24 hours; then remove the tinted film from the reel or rack, rewinding each sequence back onto its small reel.

10. Repeat steps 5 through 9 for each additional color to be used.

11. Reassemble the film according to your notations and identifying threads, using tape splices and removing the threads as you complete each splice

12. Relubricate the film and project the tinted reel. You can now use a silicone treatment if so desired. You will not recognize it as the same film with which you started, but your enjoyment will be greatly enhanced.

COLOR WHEELS

Collectors who would like to obtain similar effects but do not wish them to be permanent or cannot spare the time will find the use of a color wheel placed in front of their projector to be a satisfactory substitute. The color wheel will also serve as a satisfactory substitute in the event you have a film which has had a silicone treatment and no untreated print can be found. These circular metal plates rotate on a stand and have a number of cutouts which contain different colors of gelatin or cellophane. As the color requirements on-screen change, you merely turn the wheel to the desired color, interfering with the projected picture only momentarily.

Color wheels can be purchased in theatrical supply houses, or you can make your own, using a 6-inch circle of stiff cardboard, a compass, and a sharp knife or razor blade to cut out the required number of holes approximately 1½ inches in diameter. Many stationery stores carry small pieces of colored cellophane, which can be taped in front of each cutout. Punch a small hole in the center of the wheel and fasten it with a thumbtack to the base. Place the finished wheel in front of the projector so that the image passes through the colored opening in the wheel and project your films, rotating the wheel as desired. (See Fig. 7-4.)

Professional attachments for adding color to black-and-white films were not uncommon in the early days of 16mm. Some models of the Bell & Howell 16mm projector were often equipped with a Filmo accessory unit for this purpose. In the form of a 6 x 4 inch metal rod with five different glass color filters in swiveling mounts attached ¼ inch from each other at one end, it became an integral part of the projector when attached to the side of the lens barrel mount. Each filter could be swung in or out of place in front of the lens with the touch of a

Fig. 7-4. A homemade color wheel in use.

finger and did not interfere with focusing. Filters could be used independently or in combination with others. Although these units can occasionally be found today in pawn shops and camera stores catering to collectors of the odd and unusual, it would be easier for a person handy with metal working tools to construct his own variation of this useful accessory.

CHAPTER VIII

THE UNSILENT SILENTS— ADDING SOUND

No indeed, silent films were not silent. They were invariably accompanied by music, whether from a tinkling out-of-tune piano in the neighborhood theater, played from memory by "The Professor" as he watched the screen; the full dress orchestra at the Roxy led by Hugo Reisenfeld, acknowledged virtuoso conductor; or Paramount's magnificent Mighty Wurlitzer played by Jesse Crawford. Mood music was an integral part of the success of the silent film for two decades and had reached the state of a fine art when Warner Brothers' Vitaphone shattered the silent screen with synchronized sound.

The early movie producers, quickly discovering that mood music played during the filming of a picture emotionally involved the actors in their roles, made music a part of many production sets. Exhibitors applied this knowledge to their audiences and found that when the correct music accompanied the projection of a film, viewers were completely unaware of its presence, but if the music stopped or did not match the mood of the picture, the audience became restless and noisy. Film companies soon found themselves in the business of providing exhibitors with complete and detailed musical scores to be played with their pictures, and by 1916 any theater which did not provide accompanying music with its picture was not considered worthy of its name.

A CREATIVE CHALLENGE

As in the case of tinting your films, a musical score will contribute a great deal to the enjoyment of your collection and will create a degree of authenticity which you may wish to inject into your hobby. Just as the

model railroad enthusiast who begins with one train and a circle of track gradually acquires the desire to add an aura of realism with scale buildings and miniature landscaping, the classic film collector who starts his hobby with a projector and films will look for ways to exercise his creative ingenuity. Adding music to your films is exactly the challenge to satisfy that need.

COMMERCIAL SCORES

The easiest manner in which musical scores can be acquired is to purchase them pre-recorded on tape from one of the organizations listed in Appendix II. A considerable number of the available classic films have been scored and recorded; some have even been taped during actual performances, which utilize the original cue sheets and feature Arthur Kleiner, Paul Norman, and others of the handful whose reputations place them among the select few of a vanishing profession, piano and organ accompaniment. Costing about $2.50 per reel of film they are to accompany, these taped scores can be obtained at playback speeds of 3¾ or 7½ inches per second. Even if you decide to make your own musical scores, the purchase of some of the pre-recorded tapes will serve you well by providing examples of musical choices and correct cueing, which will serve as a guide in designing your own.

CREATE YOUR OWN

Until the advent of the tape recorder, it was impossible for the collector to recreate the exact mood to accompany each sequence within a film. At best, he was limited to playing a phonograph record which provided a general mood, unless he just happened to be a proficient musician with his own piano or organ. But now, any collector skillful enough to operate a recorder and stop watch can score his own films as precisely as he wishes. I assume that the reader is familiar with tape recorder operation; if not, the purchase of a book on tape recording and editing of tape is recommended.

MUSIC FOR MOODS

Although no single musical score is "best" for a particular film, there are basic moods, and most music other than vocal renditions, string quartets, and choral selections can be successfully used. Thus, a necessary

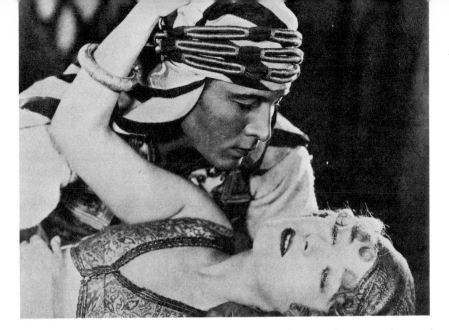

Fig. 8-1. The love scenes in **Son of the Sheik** call for a tender and romantic background, but try a touch of Wagner or even a dramatic pipe organ piece for the unmasking of the "Phantom of the Opera."

first step for the collector interested in scoring his own films is to become reasonably familiar with a representative selection of the almost unlimited music on records—their content and the moods they suggest. Orchestral music is best, with symphonies, overtures, and suites offering the most desirable choices.

Symphonies

Each movement of a symphony—there are usually three or four—presents a different mood. The first movement of Beethoven's Fifth Symphony is a very fast allegro; the second is smooth and slow. The third is light and lilting; the fourth is in march tempo. Symphonies usually contain contrasting fast and slow tempos and may be used as background themes for an entire film.

Overtures

Overtures often resemble symphonies in presenting a series of moods. A portion of Rossini's famous William Tell Overture is known to almost everyone who ever watched Saturday matinees, listened during the golden age of radio adventure shows, or even sat in front of a television set. Although few would recognize the first three parts, the fourth and

final part which opens with a Swiss trumpet call is universally known—perhaps not by its correct name but certainly in connection with the Lone Ranger. This closing of the William Tell Overture has become famed as the background music for thousands of chase sequences in motion pictures, and although overworked as such, never fails to provide the correct and rousing musical finish, whether for a dramatic action sequence or a comedy chase scene.

Suites

A suite contains quick changes in mood, and the more modern ones such as Grofe's Grand Canyon Suite are better suited for background music. The contrasting high and low tones of many suites require the collector to smooth out the abrupt changes for use in a score by controlling the volume when recording—a skill which is developed with practice. Although much effective music is found within suites, it is better to avoid their use until you have scored a few films and are more familiar with the techniques.

SELECTING MUSIC

How can you narrow down the available music to fit your needs? A basic collection of recordings should be acquired; about 20 carefully selected records will supply you with most of the music needed to score any classic film. Spend a few evenings listening to a variety of recordings. Keep a pad and pencil handy and use a stop watch or a watch with a sweep second hand. Don't try to concentrate and don't try to categorize the music as fitting a particular film—this distraction above all others requires a concentration which will interfere with your emotional reaction to the music. Let your mind wander freely with the music and jot down whatever reactions you have to each band of the record as it plays. Don't try to describe the music elaborately; a simple descriptive word or two will be sufficient to identify the mood. Your final result would look something like the following:

Calm and Peaceful

Hungarian Rhapsody II (Liszt)
Narcissus (Nevin)
Spring Song (Mendelssohn)
William Tell Overture, Parts 1 & 3 (Rossini)

Sad and Slow

Andante Cantabile (Tschaikowsky)
Largo—New World Symphony (Dvòrak)
River Moldau (Smetana)
Valse Triste (Sibelius)

Light and Frothy

Anitra's Dance (Grieg)
Benvenuto Cellini Overture (Berlioz)
Dance of the Hours (Ponchielli)
Mignon Overture (Thomas)

Gay and Lilting

Dance of Mirlitons (Tschaikowsky)
Entry of the Gladiators (Fucik)
Parade of the Wooden Soldiers (Jessel)
Poet and Peasant Overture (von Suppe)

Fast

Bolero (Ravel)
Flight of the Bumble Bee (Rimsky-Korsakov)
Hungarian Dances 5 & 6 (Brahms)
Hungarian March (Berlioz)
Light Cavalry Overture (von Suppe)

Majestic

Aida Grand March (Verdi)
Die Meistersinger Overture (Wagner)
Marche Slave (Tschaikowsky)
Siegfried Funeral March (Wagner)

Wild and Tempestuous

Die Walküre—Ride of the Valkyries (Wagner)
Flying Dutchman Overture (Wagner)
1812 Overture (Tschaikowsky)
William Tell Overture, Part 4 (Rossini)

Mysterious

Cathedral Engloutie (Debussy)

133

Dance Macabre (Saint-Säens)
Fingal's Cave Overture (Mendelssohn)
The Sorcerer's Apprentice (Dukas)

Dance

Blue Danube Waltz (Strauss)
Emperor Waltz (Strauss)
Skater's Waltz
Tales from the Vienna Woods (Strauss)

SOUND TRACK RECORDINGS

Original sound track recordings of Hollywood film scores are quite useful but fit into several categories. They represent a completed version of exactly what you are trying to achieve—a musical score to accompany a film. These will require careful listening since not all of the music on each recording will be useful. Some parts will not appeal to you, but keep a written record of the selections or portions of selections which impress you. Before long, you will have accumulated a list sufficiently large to provide a variety of music without constant repetition of a few selections. Other possible choices are the dozen or so records available which contain music especially recreated for silent movies and also organ music, which is plentiful and fits well into many scores.

Until you become thoroughly familiar with the technique of scoring your films, don't attempt to mix classical works, sound track recordings, and organ music within one film. Choose one style of music and remain faithful to it throughout the entire film. After a certain amount of practice, you will be able to discern where such mixing can be done effectively but until then, avoid the discordant note in the viewer's ear caused by a full orchestra suddenly dissolving into an organ solo and emerging again.

TIMING YOUR FILMS

Once you have secured a basic list of music and categorized it according to moods, the next task is to select a single-reel film for scoring, breaking it down into sequences according to their mood requirements. This requires screening the film with a stop watch in hand, jotting down both the mood and length of each sequence. Remember that it is not

necessary to change the music for every scene change or every mood change within a sequence. Don't bother cueing music for a scene less than 60 seconds in length, unless you specifically wish to emphasize one in particular. Such scenes are usually so short that viewers do not realize that the accompanying music does not fit perfectly. Construct a cue sheet which identifies the opening and closing of each sequence, along with its dominant mood requirement and duration. You will need this information for both the selection and the actual cueing of music later.

DESIGN THE SCORE

Once you have broken down the film into its major mood requirements, the next step is to select that music which best matches your needs. Remember that repetition is sometimes necessary to sustain an original mood or even to remind the viewer subconsciously of the similarity one sequence has to a previous one. A battle sequence punctuated by hospital scenes of the wounded being treated is one instance in which repetition broken by interludes of tranquil music would be effective.

In highly tense and dramatic moments, absolute silence can be more appropriate than any music you could possibly choose. The scene of Lincoln's assassination in *The Birth of a Nation* (see Fig. 8-2) is best handled with lilting music during the sequence in Ford's Theater up to the moment of Booth's fatal shot. Abrupt silence follows until the camera picks up Booth leaping to the stage, and then the music resumes in a somber vein.

Fig. 8-2. The horror and shock of Lincoln's assassination in **The Birth of a Nation** is intensified by an abrupt break in the musical score. Hold the silence until Booth's leap to the stage is completed and resume with a faster tempo.

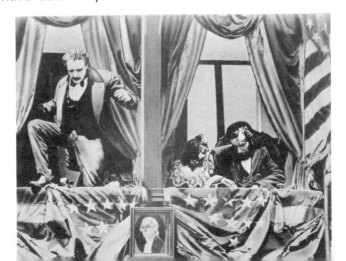

TAPE THE SCORE

Once you have matched mood selections to each film sequence, you will need a tape recorder which has a pause button and a patch cord to allow recording either from your hi-fi or stereo directly, or from its speaker terminals. Don't attempt to record the musical selection using a microphone placed in front of the speaker; it will pick up every extraneous noise in the room. If you are sufficiently well versed in the use of your recorder, it is possible to capture each desired musical selection in sequence on one reel of tape, using the pause button while you change records and cue up the next band to be recorded. Otherwise, it will be necessary to record each band completely, editing the final tape to retain only the required lengths of each selection desired. The final tape should contain mood selections which match the cue sheet you originally designed for the film in length and sequence.

Fig. 8-3. Although the new cassette systems offer the ultimate in portability and ease of operation, their use requires precision timing. Attempting to edit a cassette tape is a near-futile effort for the amateur.

Fig. 8-4. Best results are obtained using a reel-to-reel recorder such as the Sony 104-A. The removal of unwanted (or insertions of additional) portions of music is much easier with a reel tape. Once the tape score is completed, there is no reason why it cannot be duplicated onto a cassette for use, if desired.

USING THE FINISHED SCORE

1. Splice a tape leader at the beginning and thread the tape in the recorder for playback.

2. Thread the film in your projector and run it until the title appears on the screen.

3. Switch the projector to the still picture mode, using the manual threading knob to back up to the first frame if necessary. You are now ready to project your first scored film.

4. Start the tape recorder, watching the leader carefully in preparation for returning the projector to its forward mode.

5. As soon as the leader passes completely by the playback head, the music should start. At this moment, return the projector to forward.

Although you will be pleasantly surprised by the effect which accompanying music will provide when properly keyed to your films, perhaps the greatest enjoyment comes from the fact that this achievement is your own creative response to the challenge of authenticity posed by your collection.

MAGNETIC SOUND

Once your score has been taped and checked by playing it with the film, and adjustments (if any) have been made by shortening or lengthening musical passages, you may wish to transfer it directly to the film to assure correct synchronization, without the bother involved in trying to start the recorder and projector simultaneously. Over the past decade, manufacturers have perfected the addition of sound to silent prints by placing a thin coating of magnetic oxide similar to that used on recording tape along the edge of the film. Magnetic sound projectors contain a magnetic tape head and amplifier and include, in essence, a built-in tape recorder perfectly synchronized with the picture on the screen.

16mm Magnetic Sound

Although it is technically possible, the addition of a magnetic sound track to 16mm film is virtually ruled out for the collector by the extremely expensive 16mm projectors required to record and play back the sound. Although at least five excellent machines are manufactured presently, only the Kalart-Victor 70-15MP (priced at about $700) can be bought for under $1,100; the remaining projectors range from about $1,100 to $1,500. Because of this high initial cost, 16mm magnetic sound

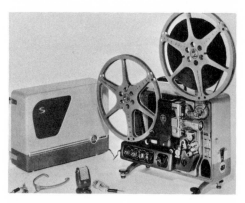

Fig. 8-5. The Bolex S-221, a 16mm projector capable of projecting either optical or magnetic sound. Although all of the projectors of this type currently manufactured are high in quality, their price tags discourage collectors from the use of magnetic sound with their 16mm films.

projectors have not proved popular in the several years they have been manufactured and are seldom seen on the used equipment market. Even when an occasional used model is offered for sale, its cost is still excessive for the average collector.

Only one conversion unit for adding the recording and playback requirements of magnetic sound to the existing optical sound* capability of 16mm projectors is presently available and by the very nature of the problem it is designed to solve, the Magnesound MAG-3 is a rather costly (over $200), awkward unit which will function only with certain models of the Kalart-Victor projector. This requires the operator to remove the optical sound drum and exciter lamp, replacing it with the special magnetic drum each time he wishes to change the projector's optical reproduction mode (which must be used for all commercially produced 16mm films of current vintage he might borrow, rent, or buy) to magnetic.

*Optical sound is a photographic reproduction of sound waves, which looks like an oscilloscope pattern. When it passes through a photoelectric beam, the optical sound track breaks the beam, creating minute electrical waves transmitted to the amplifier and converted to audible sound. Optical sound is printed in conjunction with the negative and is cheaper for mass reproduction as well as permanent.

The collector who does use magnetic sound in 16mm will have to send his prints out to a commercial laboratory for striping, since no striping machines exist in this size for home use. If the film stock on which his print was made has sprocket holes on both sides of the film, he will receive a 30-mil stripe placed between the sprocket hole perforations and the picture area on one side of the film; if the film stock has only one set of sprocket holes (many used 16mm prints made in the thirties and forties were printed on single perforated or "sound" stock), he will receive a 100-mil stripe along the "unperforated" edge. For this service, he will pay 6¢ per foot in lengths under 400 feet; 4¢ per foot if the order exceeds 400 feet in length. One point of interest—the wider the magnetic stripe, the better the frequency range (the highs and lows) of reproduction.

8mm Magnetic Sound

Magnetic sound reproduction has made its greatest impact in the 8mm field, first with Standard 8mm film and then with Super 8mm. Since an acceptable optical track requires greater width than a magnetic track, attempts to design a practical optical sound system for either 8mm format have been unsuccessful up to now because of the extremely small area available for its placement on the film. While Viewlex has finally achieved what it considers to be a breakthrough with 8mm optical sound, its system has not been adopted by any other manufacturer, most of whom have publicly gone on record with Eastman Kodak that the future rests with magnetic sound, and no classic films have been released with an optical track. Although the 8mm magnetic sound field has mushroomed in the past few years, it has not done so to the great degree predicted a few years back by its optimistic followers but sufficiently to become a strong contender for the collector's attention. For example, the recent, strong revival of interest in the work of W. C. Fields has brought many new collectors into the fold, and because of copyright restrictions, those films of his that have been made available to date are mainly the early sound short subjects.

At least ten quality Super 8mm magnetic sound projectors are presently being marketed in the $300 to $600 range, three of which are dual function, also accepting Standard 8mm. Although no longer manufactured, but excellent buys in the used Standard 8mm sound arena, the Kodak, Fairchild, and Sears projectors are still found on camera store shelves. Other discontinued Super and Standard 8mm sound projectors are also available, but the collector interested in such a machine should

139

a. c.

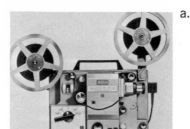
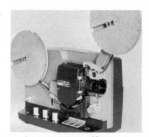

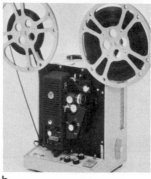

Fig. 8-6. Essentially a tape recording device permanently synchronized with a projector and using a magnetic stripe on the edge of the film, 8mm sound projectors are becoming more popular every year. Presently, they range in price from $350 to $600. Some, like the (a) Eumig Mark-S-709 will record and reproduce sound on both Standard and Super 8mm; (b) the Kodak Instamatic M100 is designed for Super 8mm only, as is (c) the Bolex SM-8.

b.

make certain that it conforms to the now prevalent industry standard, which specifies that the sound be placed on the film 18 frames ahead of the picture to which it is synchronized in Super 8mm; 56 frames ahead in Standard 8mm. This lead point is necessary because the sound reproduction apparatus is placed below the aperture.

Some early machines used lead points which conformed to their particular design, until standardization was agreed upon. No longer manufactured but still available in some camera stores, conversion units for 8mm magnetic sound each had a frame lead of their own, and compatibility with any other system is out of the question. These were designed specifically for home movie fans who wished to add sound to their own films, and you should avoid them as unsuitable for your collecting needs.

The collector interested in 8mm magnetic sound can either have his footage striped by a commercial laboratory, as must the 16mm enthusiast or stripe it himself. When a commercial laboratory does the work, the price and footage requirements are the same as for 16mm and both Standard 8mm and Super 8mm will receive a 30-mil stripe. Standard 8mm film is striped between the sprocket holes and its edge; Super 8mm carries its stripe along the "unperforated' edge, with an additional stripe between the sprocket holes and the other edge for balance.

140

Fig. 8-7. One of several varieties of imported sound stripers for 8mm film, the Supersound features simplified threading and ease of operation for the collector who wishes to laminate his own magnetic track. Stripers are available in both Standard and Super 8mm.

MAGNETIC STRIPING

Magnetic striping can be done by two processes. Either a prepared magnetic stripe is laminated to the film, or a liquid solution is applied as a stripe.

Lamination

This process is easily adapted for home application. It uses a film striping unit, a roll of magnetic stripe, and a special adhesive solution. It is also well to clean your films with whatever special cleaner the striper manufacturer recommends. No American manufacturer sells a film striper for amateur or home use; the few available models are currently imported, mainly from England where home magnetic striping is much preferred to that done by commercial laboratories, because of the lower cost.

The early lamination machines released to the market a few years ago proved to be less than satisfactory at the time. The magnetic stripe often varied in reproduction quality, and the striping adhesive had a tendency to dry out when storage conditions were not optimal. The stripe separated from the film, evoking untold cries of anguish from users who found their sound tracks ruined as a result. For a short time, Argus imported a machine which it sold under its own brand name in this country, but mechanical difficulties with the unit combined with the above

141

problems to force it from the market. Occasionally, these stripers can still be found for as low as $30 in camera stores whose buyers had a soft spot for a salesman's hard luck story. Although they are still in their original factory cartons and sold at reduced prices, walk right on by.

Stripers presently available cost in the neighborhood of $60, but the stripe and adhesive cost only about 1¼¢ per foot. The procedure of application is simplicity itself and requires no more talent than the ability to thread the film and stripe around several rollers and keep the adhesive container full. It is advisable to pay particular attention to the directions accompanying the specific striper you purchase for special instructions as to pressure, winding speed,* and storage recommendations; they vary from unit to unit. You might also keep in mind that imported equipment often appears and disappears with amazing rapidity, and supplies for the striper you buy today may not be available tomorrow.

Lamination is an enjoyable project, and if you have sufficient films on hand to merit the application of a stripe, you might be able to amortize the cost of the striper quickly enough to offset any loss due to lack of availability of the replacement stripe and adhesive at a future date, but the risk that the finished sound track will one day separate from the film is an ever present one and should be weighed carefully before you decide to move in this direction. The striping of 2,100 feet of 8mm film will pay for the striper and materials; any footage striped beyond that quantity will cost only the price of the materials, or about 1¼¢ per foot.

Liquid Striping

In the past, the liquid striping process could only be done by a laboratory equipped for its application. It will not come off once applied. Liquid striping tends to be more uniform in quality, but don't deal with firms which offer a bargain price. Cut-rate offers mean economy somewhere on the part of the laboratory, and it may well be in the quality of the coating. Storage is the same as for films within the stripe, except for the usual precautions required to preserve the magnetic track from accidental erasure. Care should be exercised in cleaning films which have been striped as several commercial cleaners have a tendency to soften and smear the stripe. Test before using by applying a small amount to the striped leader. Dry splicing for repair of broken magnetic sound

*Abbe Films in New York City is now distributing a motorized striper, which is priced at about $60, designed to handle either Standard 8mm or Super 8mm.

films is highly recommended, using the special sound tape splices to avoid hissing, popping, or squealing noises as the splice passes by the sound reproduction head.

RECORDING YOUR SCORE

Magnetic tracks can be added at any time and can be erased if you have no further use for them, allowing you to change the musical score if you desire. Once the film has been striped and your score compiled, it is a simple matter to record the sound to the stripe. The instruction booklet accompanying both the projector and the tape recorder should be consulted for specifics pertaining to the particular combination of equipment

Fig. 8-8. Composed of four stories spanning the history of man, D. W. Griffith's epic **Intolerance** runs three hours and contains lavish scenes never again duplicated. Scoring this film is a lengthy and challenging task.

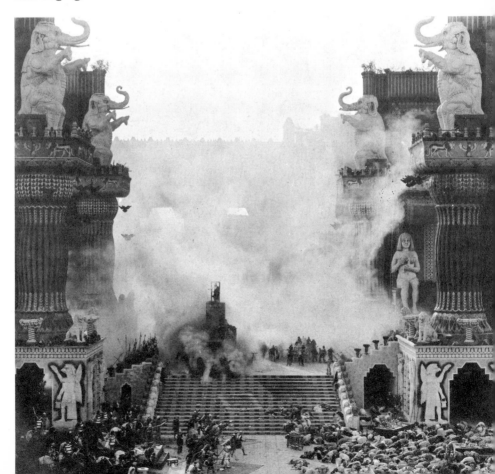

you are using, but the following procedure can generally be followed with assurance of success:

1. Thread the projector in the normal fashion, with the leader (which must also be striped) positioned in the aperture gate five frames from the first title frame. You will need this small leeway to allow the machine to build up to a constant speed after starting. Make certain that the tension around the sound drum and magnetic head is correct.

2. Thread the tape recorder with your completed score, positioning about 15 inches of the leader in front of the tape head so that the music will not begin as soon as you press the forward control. This is important as you need sufficient time after starting the tape to turn on the projector.

3. Connect the external speaker or monitor outlet of the tape recorder with the projector input.

4. Turn on the projector amplifier and allow it to warm up, unless it is solid-state. Do the same to your tape recorder.

5. Pre-set the volume level of both machines, making certain that the projector is set on sound speed (24 frames per second).

6. Start the tape recorder, position your hands on the projector controls, and watch the tape leader. As it passes through the head area, turn on the projector and record control. Watch the recording indicator carefully, quickly making any needed adjustments in volume level.

7. Project the entire film and as "The End" appears on the screen, fade out the projector volume, and let the film run through the projector.

8. Shut off the tape recorder and rewind both tape and film.

9. Rethread the film at the beginning and project, noticing the quality of recording and synchronization.

MIXING NARRATION WITH MUSIC

Some projectors have a built-in mixer control which allows you to use the microphone that comes with the projector to superimpose your voice over the music, adding narration to accompany the score. You will find this technique especially valuable when used with a historical film, such as *The Ruins of San Francisco, 1906* or *The Early Days of Motoring*. Using the text material provided by the subtitles as a basis, a little work at the library will allow you to write a script which incorporates additional interesting information pertinent to the film. Cut out the subtitles before striping, and you will find that the narration strengthens the historical value of the film. It will also give you a feeling of accomplishment

144

to invite a few friends in for an evening and screen a historical documentary for them, complete with your own voice.

Although prints with a sound stripe are compatible for use with a regular silent projector, it is not recommended as the film path of some silent projectors may demagnetize or otherwise injure the magnetic stripe. Mastering the adding of tints and combining sound with your collection requires little more than practice of the techniques just covered, but once you have successfully accomplished these feats, you are ready for the expansion of your collection in new and different directions.

CHAPTER IX

MOVIE MEMORABILIA

Now that you have reached this, the final section of our journey through the land of the classic film collector, I feel certain that you are on your way to becoming a confirmed collector—one who has been smitten by the film bug and whose friends will look slightly askance as you loudly proclaim the merits of the silent western over last night's psychological oater on television. If I am correct, you will soon cross that fine line which separates the novice from the ardent collector. In fact, you may already be aware that there are other additional interesting facets to your hobby besides film collecting itself.

Fig. 9-1. The cover of a serial press book. Over 50 years old, its market value to collectors is $75.

MOTION PICTURE HISTORY

First of all, you will probably want to know more about the era in which your films were made and the personalities whose immortality is guaranteed by that thin white beam of light which pierces the darkness of your living room. Recognizing this, Blackhawk Films has undertaken a most unusual but worthwhile practice of providing an introduction to each of its classic film releases as an integral part of the film. Written by authoritative persons in the field, this introduction precedes the film and is designed to provide a capsule of interesting background knowledge or little-known information concerning the film, its production, and cast.

Fig. 9-2. The early film producers distributed their own newsletter weekly to exhibitors, describing current and forthcoming pictures. This **Selig Polyscope News** of April 29, 1910, in its folder is worth $12.50.

Other distributors provide a similar service in the form of printed film notes designed to acquaint the viewer with a critical appraisal of the film and its historical role in the development of the cinema.

Until recently, much of what passed as film history was purposely distorted, sensationalized, or fictionalized in order to assure the sale of sufficient copies for the publisher to earn a profit—still the appealing aspects of fan magazines. The practice has not been abandoned altogether, but the resurgent interest in motion picture history has led to the publication of a growing number of serious and accurate volumes in the past decade.

Too many years after it should have been done, the history of the industry is now being put together by bits and pieces; unfortunately, many of those who helped create this history took a substantial wealth of knowledge to the grave unrecorded. The list of books recommended in Appendix III contains suggested readings for those collectors interested in the background of their films. Anyone who investigates a few of these

writings in film history will soon discover that this emerging area of serious Americana has its own meticulous researchers, such as Gordon Hendricks, as well as informative, lively, and opinionated observers, such as William K. Everson.

Fig. 9-3. Scripts are especially interesting and difficult to locate. The original story of **Pirate Gold** contains notations by its writer and director, giving a good insight into production techniques of 1920.

Fig. 9-4. Pennants of cheap felt inked with the picture and name of the star were given away by theaters as advertising for certain films. Today, faded and worn, they sell for $7.50 and up.

If you have not already become acquainted with this aspect of collecting, the purchase of some of the books listed in Appendix III will drive the fact home with force—motion picture history has become big business! Out of print volumes sell for fabulous prices in some cases, and demand usually exceeds supply, sending prices skyrocketing. Until Simon and Schuster reprinted Terry Ramsaye's classic *A Million and One Nights* in 1964, the few copies available for purchase on the used market brought up to $325 each, quite an appreciation in value from its original price of $7.50 when first published in 1926. For those who still desire first editions, the price of this two-volume set has dropped to $125, but reprints

can be bought for under $10, making this rare work available for the first time in many years to all who want it.

MEMORABILIA

But collecting does not end with either films or books. The producers of the silent era used advertising gimmicks, publicity photographs (or "stills'), posters, press books (tips for exhibitors in publicizing forthcoming films), and hand colored "Coming Attraction" lantern slides (3¼ x 4¼ inch glass); even shooting scripts and stars' autographs bring money on the collectors market today. For example, in 1914 Universal distributed literally millions of tokens to accompany release of its serial, *The Broken Coin;* every fan attending received one. Fifty years later, this token, or "Broken Coin," as it is known, brought $50 at a coin sale. (See Figs. 9-5a and b.)

a. b.

Fig. 9-5. The "Broken Coin." This handsome token was distributed by Universal in 1914–15; recently one sold for $50 at a coin auction.

Collectors who wish to expand their hobby to include a variety of these materials will find an interesting challenge in locating those items of particular interest. On a small scale, the investment of money in these artifacts of the silent film is as good a way for the average person to hedge against inflation as are rare books or art masterpieces for the wealthy. Ten years ago, I acquired a copy of Robert Grau's *Theater of Science,* a book published in 1914, which deals with the motion picture industry and the outstanding personalities of the time (most of whom are long forgotten), for the sum of $5. Today it is bringing $65 in the market place—a rise in value considerably greater than the 5 to 5½ per cent interest paid on my savings account and safer than the stock market.

149

Fig. 9-6. Advertising giveaways took all forms during the silent era, but few fascinated the younger fans as much as the 1½-inch lapel buttons handed out at serial chapters. Although literally millions were given away from 1914 to 1929, few have survived. These two from the 1916–17 period are from the collection of Tom Dino. Their worth? Twice as much as the "Broken Coin"!

Alert collectors soon discovered that the prime sources for stills and other souvenirs of the era are the silent stars themselves. One by one, many have been hunted out of the obscurity which has enfolded them over the years and have been besieged by requests for autographed pictures until they have none left. Others arbitrarily destroyed these relics of a completed career, much to their dismay today. This is the case with one sad director I know who destroyed 10,000 photographs several years ago, just before Los Angeles prohibited the burning of rubbish by home

Fig. 9-7. Many collectors acquire posters and other advertising papers to accompany their films. Although **The Lost World** is available to collectors in a five-reel Kodascope version, one-sheets such as this are hard to come by.

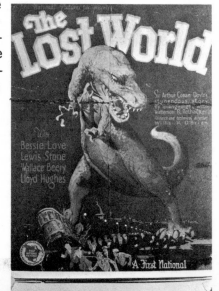

owners. The small extra space he obtained in his garage as a result cost him approximately $25,000—the fair market price for which he could have sold the pictures to collectors.

It is almost impossible to establish guidelines for reasonable prices to pay for stills and other memorabilia with any degree of accuracy. The market is determined in a rather irrational manner, almost entirely on the basis of scarcity and desirability, with materials priced accordingly.

SCARCITY AND DESIRABILITY

One complicating factor is the tendency to tie the price asked to the year of production. Stills from a particular 1928 film are deemed to be less desirable than those from one of 1918 vintage, even though the available stills from the 1918 film may be much more abundant than those from the 1928 production. Although certain collectors and most dealers regard souvenirs of the earlier films as most desirable, this is not always the case.

Fig. 9-8. All movie fans remember the posters outside theaters announcing their favorite films. This one-sheet from a chapter of a Ruth Roland serial has survived almost half a century and hangs in the window of a Hollywood dealer, priced at $65.

Expect to pay a premium for anything relating to the very well-known stars such as Charlie Chaplin, Douglas Fairbanks, William S. Hart, and Valentino, whereas anything relating to the comparative unknowns such as Richard Talmadge, Jack Hoxie, Ramon Navarro, and Richard Dix can be purchased much more reasonably. Plan to pay more for items relating to the milestone films than for those from less publicized pictures.

You can be certain that a much higher price will be charged for an original still, regardless of its condition. The prices of torn or faded originals do not include a reduction for the defect; an original is an original to the dealer. Some collectors and dealers make copy negatives of their original stills and produce duplicate prints which are sold at reasonable prices, usually $1.50 or less per print. But even if you purchase an original still, don't delude yourself into thinking that it is the only one of its kind; thousands of prints were made from each negative, and a number of identical original stills remain in existence and circulation today.

It is a crazy, mixed-up way to do business, but more and more specialty book shops in the New York City and Los Angeles areas are acquiring a line of classic movie materials as they watch the handsome profits mount up for their competition across the street. There seems to be nothing but rising prices in the foreseeable future, opening up another interesting and lucrative area for the collector who wishes to broaden his interests.

TREASURE HUNTS

Regardless of where you live—in a metropolitan area, a smaller city, or a rural hamlet—the search for artifacts from the early days of the movies can take on all of the aspects of a treasure hunt. Although a great many of the films and supplemental materials have been destroyed over the years, either deliberately or inadvertently, much remains to be discovered, and collectors interested enough to take the time are realizing a substantial profit in addition to building up their own collections.

Where to Look

There are a number of ways to initiate a search for whatever supplementary material you are interested in, whether stills, lobby cards, coming attraction slides, press books, or other items. Many of your leads will prove to be worthless, but there is always the possibility that you will find the pot of gold at the end of the rainbow, and one such reward always seems to offset the many fruitless attempts.

1. Contact the management of neighborhood theaters and explain what you are looking for. Many times, they will be most happy to give the contents of a downstairs junk room to anyone who will clean it out, and usually a few prizes turn up in this manner.

2. Try to determine who the previous owners of the theaters were, as well as the names of any of the old-time roadshowmen who traveled

Fig. 9-9. Bought by the author in unused condition for $5, this advertising giveaway of 1916 accompanied the release of a serial dealing with the supernatural.

Fig. 9-10. When assembled according to directions, this strange object was supposed to perform as a ouija board. Its recent sale for $40 indicates the appreciation in value which movie memorabilia have undergone in the past few years.

from place to place exhibiting films in the silent days. These people may well have a myriad of things stored in their attics or garages. I was once paid $10 to clean out a garage filled with magazines and lobby cards, which the owner no longer wanted, if I would only dispose of them for him. He refused to believe they were worth money.

3. Contact real estate agencies handling theaters that have been closed down and abandoned. Since deserted theaters were usually closed during the first onslaught of television's competition, they are often very lucrative sources of materials; whatever was there 10 or 15 years ago is still there. One such theater in Vermont was finally sold to a discount supermarket chain, and over $5,000 worth (the market value in 1959) of trade journals, lobby cards, and stills was sold by the new owners for scrap paper at 50¢ a pound.

4. Keep a close watch on pawn shops and bookstores selling used magazines. Although magazines seldom turn up in pawn shops, many other interesting items do and usually the prices are below market value.

5. Attend auctions that seem promising to you from the descriptions of merchandise to be sold. Many prized items have been discovered by collectors in this manner and for a most reasonable price.

Be willing to pay a fair price to the owner in whatever dealings you undertake for such materials. Unfortunately, if he suspects that such things have a value, the asking price may suddenly become grossly inflated as a result, but establish in your own mind what they are worth to you and stand by your offer. Happy hunting, collector!

CLASSIC FILM DISTRIBUTORS

AMERICAN DISTRIBUTORS

Blackhawk Films
1235 West Fifth Street
Davenport, Ia. 52808

Castle Films
221 Park Avenue South
New York, New York 10003

Columbia Pictures Corporation
711 Fifth Avenue
New York, New York 10022

Cooper's Film Rental Service
Northedge Shopping Center
Eaton, Ohio 45320

Edward Finney
1578 Queens Road
Hollywood, Calif. 90069

Entertainment Film Company
850 Seventh Avenue
New York, New York 10019

Essex Film Club
263 Harrison Street
Nutley, N. J. 07110

Film Classics Exchange
1926 South Vermont Avenue
Los Angeles, Calif. 90007

Gaines 16mm
14544 Vanowen
Van Nuys, Calif. 91405

Glenn Photo Supply
4031 Gloria Avenue
Encino, Calif. 91316

Griggs Moviedrome
263 Harrison Street
Nutley, N. J. 07110

Historical Films
Box 46-505
Hollywood, Calif. 90046

I. K. McGinnis
Box 5803, Bethesda P. O.
Washington, D. C. 20014

Minot Films, Inc.
Minot Building
Milbridge, Me. 04658

Movie Classics
P. O. Box 1463
Philadelphia, Pa. 19105

Movieland Films Inc.
6039 Hollywood Boulevard
Hollywood, Calif. 90028

Movie Wonderland
6116 Glen Tower
Hollywood, Calif. 90072

Nick Fiorentino
60-B Newark Way
Maplewood, N. J. 07040

Norward Enterprises
P. O. Box 265, Midtown Station
New York, New York 10018

Parkchester Films
1314 Leland Avenue
Bronx, New York 10472

Sears and Roebuck
In all cities

Select Film Library
115 West 31st Street
New York, New York 10001

UA-8
555 Madison Avenue
New York, New York 10022

FOREIGN DISTRIBUTORS

Bouchard, Enrique
Charcas 2762
Buenos Aires, Argentina

Butcher's Film Service, Ltd.,
175 Wardour Street
W. I. London, England

C. W. S. Film Department
Transport House, Smith Square
S. W. I, London, England

Film Office
4 Rue de la Paix
Paris, France

John King Film House
East Street
Brighton 1, England

Kirkham Film Service Ltd.,
Warrington, England

Kodak Pathé S. A. F.
39 Ave. Monteigne et
17 Rue Françoise
Paris (VIIIe), France

Pathéscope, Ltd.,
North Circular Road
Cricklewood, N. W. 2
England

Watsofilms, Ltd.,
Film House, Charles Street
Coventry, England

Wigmore Films, Ltd. 35
Beaufort Gardens
Brompton Road, S. W. 3,
England